KLAUS-JÜRGEN SEMBACH

STYLE 1930

STYLE 1930

Elegance and Sophistication in Architecture, Design,
Fashion, Graphics, and Photography

KLAUS-JÜRGEN SEMBACH

UNIVERSE BOOKS **NEW YORK**

Published in the United States of America in 1971
by Universe Books
381 Park Avenue South, New York 10016

Translated from the German "Stil 1930" by Judith Filson
English translation © 1971 by Thames and Hudson Ltd., London
© 1971 by Verlag Ernst Wasmuth, Tübingen
Issued in Great Britain as "Into the Thirties: Style and
Design 1927-1934"

Library of Congress Catalog Card Number: 76-162926
ISBN 0-87663-153-7

Printed in Western Germany

CONTENTS

INTO THE THIRTIES

From the illustrations in this book there emerges a composite picture of a historical period, a picture that seems bright and unclouded, suggesting elegance, sophistication, urbanity, even a hint of classicism. 'Exactitude'—the term which the French state railways used to advertise themselves—could be taken as the slogan for the whole period, which would seem to have been a very conscious, well-balanced one, governed by internal and external discipline.

In compiling this book, however, I have been burdened with the knowledge that this impression of perfect harmony is deceptive. For, in politics and social history, '1930' signifies world economic crisis, constantly rising unemployment and the growth of National Socialism: chaos rather than control. The best examples of the design of the things that make up the everyday environment—buildings, furniture, vehicles—seem to stand in direct conflict with the shape of contemporary life. This contradiction is so marked that it suggests the possibility of some kind of reciprocity: on the one hand, a growing political radicalism, on the other, the conscience of a thoughtful and sensitive minority expressing itself through the medium of applied design directed at the public. Like a spell or an incantation, things were created which might be signposts to a better world. A period of great tension caused by deep conflicts can unleash the best as well as the worst in society.

Yet the spell had no effect in 1933; it could not prevent National Socialism from seizing power in Germany and bringing about the opposite of all the promise of 1930. And in other European countries, too, a reaction set in during the thirties which frustrated the development of all that had attained its peak in 1930. It would be possible to see, in this, proof of the futility of any attempt to influence the public through good design. Since the examples in this book—houses, posters, railway trains—were an integral part of everyday life, they had political significance. The close connection between politics and the social environment was clearly recognizable, especially as so much depended on progressive decisions by the State. And so we are left with the question why the ideal blueprint represented by these designs had so little effect at that time.

This apparent contradiction might lead one to suppose that the picture presented here is one-sided, that it has missed the reality of the years around 1930, that it reflects phenomena which are far too isolated and have no overall significance. In fact, however, the very idea of defining a '1930 style' arose from the evidence of how far the concept of modernism prevailed by that time. By 1930, after years of preparation and experimentation, modernism was coming to be accepted as a matter of course. This also applies to the internationalism of modern art. It is because of this that I have been able to take as the subject of this book the common factor that unites all these phenomena: their style.

Until recently '1930' had scarcely been thought of as a significant date, nor did it evoke a clear-cut image. We are used to thinking of the twenties of this century as a period of intense intellectual and artistic activity, and by contrast dismiss the thirties as an era of less distinction. What lay in between is at best regarded as a break, without dimensions, and not as a period with values and characteristics of its own, and with a definite duration. Is there reason to correct this impression? Is it possible to discover a pattern in the

different types of art illustrated here—mainly architecture and industrial design—a pattern which can unmistakably be attributed to '1930'?

This division into 'twenties' and 'thirties' is really a simplification which only separates contrasting periods and provides names for trends, without taking into consideration what came between them. It must be conceded that the contrast between the twenties and the thirties was so striking, and the reaction occurred with such violence, that any shading of nuances between the two periods is difficult. Yet there was more to the process than a gradual rise and a sudden fall; there was also a period of maturity and refinement, during which, on the basis of a common outlook, important and valuable works were being created. This was the period of fulfilment, when design possibilities were being fully exploited. This peak was reached just about 1930.

The dramatic spectacle of the exciting twenties, wide open to every kind of experiment and almost carried away by their own inspiration, suddenly succumbing to petit-bourgeois malignancy and hatred, has by now taken on the colours of a legend. The experiments and the bold advances—particularly anything that promised movement and change—are readily endowed with intrinsic value, while the question of aims and actual achievements is easily overlooked. Nowadays we are somewhat biased in favour of the fascination and excitement of that endlessly stimulating period, which was always generating something new. It is, however, wrong to judge by promise rather than by achievements. Even though that phase of maturity and adjustment which is the theme of this book lasted only for a relatively short time—strictly speaking for about six years—its existence has to be acknowledged.

To be more precise, the period under discussion is that which came after the early experimental phase, and which had outgrown doctrinaire theorizing and excessive formalism. By about 1930 the influence of expressionism was already a thing of the past, and

instead the catchword 'New Objectivity' (Neue Sachlichkeit) had been coined. In this context 'new' probably did not imply 'renewed' but was a synonym for 'unfamiliar, striking'. No doubt the choice of this name was inspired by the preference during those years for precision without atmosphere, for cool, subdued colours, a harsh metallic sheen and elegant contours. The doctrinaire angularity which only a little earlier had influenced avant-garde architecture and interior design had now been transformed into real precision, into logical forms without formalistic pretensions. The severe vocabulary of stereometric primary forms was no longer the only valid one; it had been expanded and differentiated. Even curves appeared again, though in a very highly charged form. In general there was a total absence of imprecision or vagueness.

There can be no doubt that the culture of 1930 was the end product of the developments which characterized the decade after the First World War; it is inconceivable without them. Even the mistakes and contradictions of those years must have contributed to the final attainment of lucidity and maturity. The purism of 1925 had been a necessary preliminary; it created the forms which showed the outlines of the new style most clearly. Now, however, a process of refinement took place which made elements that had previously been controversial appear natural, logical, impossible to imagine otherwise. The rigid forms loosened up and made room for subtleties that had previously not been possible. This can be seen most readily in architecture, where the severe white cube—the dominant shape of that period—now started to show a certain relief, incorporated variations in structure and material, and was transformed from a doctrinaire art form into one that took its cue from Life. At the same time architecture lost its pretensions to autonomy, and natural surroundings were again starting to be taken into consideration.

There are also signs that by about 1930 public opinion had shifted to such an extent that the new art forms met with less resist-

ance than hitherto. At least they received more support from state and local authorities, and came into fairly general use. This greater public receptiveness, and the attendant responsibilities, were also reflected in the themes of the large and influential exhibitions, of which there were surprisingly many. In the mid-twenties the 'minor arts' (in the guise of Art Deco) had predominated (Paris 1925, Monza 1925 and the first Milan Triennale exhibitions); now it was the turn of architecture, domestic interior design and consumer goods to attract the most attention. This change was heralded by Le Corbusier's Pavillon de l'Esprit Nouveau (at the Paris Exposition des Arts Décoratifs, 1925) which showed the way in which domestic architecture might develop in the future. It was thoroughly urban in its conception and did not repeat the mistake of trying to transplant a rural idyll. In 1927, at Weissenhof in Stuttgart, a complete housing estate was the subject of an exhibition. In its varied, undogmatic, unstandardized layout, Weissenhof formed an almost ideal pattern for a humane, civilized way of life. This development—in which almost all the well-known architects of the day took part—marks the beginning of our period.

In relation to the situation in Germany, '1930' also signifies the period after the Bauhaus—if we take 1925 as the key year for this school, the year when it had its greatest impact (this was when it moved to the new building in Dessau designed by Walter Gropius). By this we mean that by 1930 this institution, around which the battle to develop modernism had generally—and often mistakenly—raged, had faded rather into the background. It withdrew from its rather over-exposed front-line position, which had often served merely to provoke. Obviously in 1930 the Bauhaus was still of great importance, and indeed, under the leadership of Hannes Meyer and Ludwig Mies van der Rohe, it had taken on a wider significance; but by now its achievements were less spectacular than before, and no longer really in the forefront of public consciousness. All the same, it is hard to overestimate the influence which the Bauhaus

exercised, directly or indirectly, on the developments in design which reached their maturity in 1930.

If, as I have suggested, the period under consideration ended with the coming of National Socialism, obviously this happened first in Germany. But the shadow of this political upheaval fell all over Europe, and led to a strengthening of reactionary influences in many countries. Ultimately, a reversion to traditional attitudes became the hallmark of the thirties everywhere. Almost all attempts to go forward came to a halt, and from 1935 onwards scarcely anything of consequence was created. A contributory cause for this paralysis and resignation was probably the fact that the elimination of Germany meant the loss of the country which had provided the greatest stimulus, and which had been most decisive in putting good ideas into practice. It is only in the United States, towards the end of the thirties, that a new advance can be detected—and that largely promoted by German émigrés. The dates 1927 to 1934, suggested here as the boundaries of our period, are as precise or vague as such dates usually are. No doubt there are works which anticipate them, and also reasons for going outside them; but these dates have the advantage of being easily recognizable.

It may seem rather rash to employ such an ambitious concept as 'style' to describe the work of so brief a period. But in fact it may well turn out that the style of 1930 is essentially the style of the twentieth century as a whole, and that its influence was more far-reaching than we can appreciate today. For no other word illustrates so clearly—or so provocatively—the astonishing formal unity which prevails in all the objects illustrated here. The common factors underlying their design are unmistakable. Care has been taken when assembling them here to choose international examples, in order to demonstrate the existence of a collective consciousness.

The selection of examples from applied disciplines—architecture, industrial design, posters and photography—is deliberate. The assertions I am making do not apply to 'pure' art; the painting and

sculpture of 1930 tell a much less consistent story. One can even observe that, in the period when utilitarian design reaches its apogee, the 'pure' arts seem to take a back seat. This may be coincidental, but it may have a cause: perhaps, in tense and momentous socio-political situations, art forms with a direct relationship to real life tend to prevail over those which are less committed. In any event, it is characteristic of the twentieth century that the style of a period can more readily be recognized in its technological achievements (cars, aeroplanes, railway trains and buildings) than in its art.

In the illustrations I have tried to give an impression of the period round 1930 by juxtaposing various objects which may have no immediate connection but which complement each other. I do not mean to provide a portrait of the age—that would be another subject—but an outline of the forms in which it expressed itself. This yields revealing analogies. It is surprising, in view of the fact that painting and sculpture have been excluded, to catch occasional glimpses of a kind of Surrealist liberation of individual objects from the utilitarian purpose for which they were intended. The great precision in their structure removes them from the world of the familiar and leaves them suspended. Here, there is only the slightest difference between an intentional and an involuntary transcendence of reality. Impassivity, the total rejection of emotive and atmospheric qualities, combines with the pursuit of exactitude to create a unique intensity of expression. Thus architecture, posters, portrait photographs, all achieve a lapidary incisiveness. It is certainly no exaggeration to see in this an entirely new maturity in design, and this too points to the development of a style.

We must now examine more closely those qualities which distinguish the style of the years around 1930—precision, luminosity, transparency, immediacy, sensitivity to material, logic and freedom from sentiment and dogma. Mies van der Rohe, with the German Pavilion at the International Exhibition in Barcelona (1929), was the

first to liberate architecture from the concept of a house as an entirely closed-in structure. No longer did the cube dominate, but interpenetrating horizontal and vertical elements created an arrangement of space alive with movement. This meant that all the architectonic building elements had to be reduced to their primary forms. Walls became thin screens, ceilings became flat lids, supports were free-standing, and openings were no longer mere orifices but channels between parallel walls. Precision marked every detail. The building possessed a cool, glassy perspicuity which was the consequence of the architect's lucid exposition of the relationships between the various parts. This building gave such an impression of absolute perfection that it became the best model for teaching the principles of modern architecture, and its influence has remained paramount even to this day.

From 1930 onwards, lightness and sensitivity are qualities increasingly associated with the architecture of Scandinavia. They are present with admirable consistency in the works of the Finn, Alvar Aalto. His white buildings strike a clear, brilliant resonance in concert with their natural surroundings. Varying greatly in their design, in their use of breaks, recesses and curves, they achieve a balance which inspires well-being and a sense of confidence. This can be seen clearly in the Paimio sanatorium, with its rhythmic, outward-reaching forms; it grows out of the landscape as though freed from the laws of gravity, and without a trace of monumentality. Unpretentious and open, it succeeds in conveying an impression of euphoria and liberation.

The architecture of Le Corbusier, on the other hand, is full of conflict and tension. Relentlessly angular forms contrast with others that show a degree of modelling. Whereas the exterior of his houses remains cubical, its simplicity heightened by the sloping away of the ground around it, the interior is characterized by a use of space which is astonishing in its inventiveness and diversity. One would not guess, for instance, from the almost stark exterior of the

Villa Savoye at Poissy, that in the middle there is an inner court of a dynamic design which reminds one of the deck of a ship. The experience of walking through the house is made more special by the wide ramps which run through the interior as boldly conceived diagonals. They make an immediate physical impact, through their gentle incline, and through the fact that they physically enforce a certain hesitancy (in contrast to the usual abrupt staircases). In general, architecture in 1930 shows a latent symbolism, by virtue of its sensibility and spirit of adventure, and the severe way in which it shuns any form of decorative disguise. The sleek modelling of important details, and the cool assurance with which beautiful and costly materials are used to embellish the surfaces, heighten the spell even further.

An overriding unity of outlook makes it possible for two areas of design which would seem to have nothing in common—architecture and fashion—to be considered in conjunction. Clothes around 1930 were, like the architecture, both functional and sensuous, combining a sporting, casual look with a sense of refinement and inevitability. All unnecessary details were avoided, yet opportunities for unobtrusive luxury remained. The simplicity of the models shown in this book has a classic flavour—not only in the cut but in the pose. The great fashion photographers of that time—Edward Steichen, George Hoyningen-Huené and Cecil Beaton—express this to perfection. Their photographs are acts of homage, disarming in their elegance. Possibly their most rewarding subjects were rather surreal figures like Marlene Dietrich and Greta Garbo—women who represented the ideal type of this period, with their mixture of ethereal sensuality, clearcut emotion and almost faultless beauty.

Elegance and cosmopolitanism are the key words. It is probably no coincidence that the best posters by Cassandre, Masseau, Bayer and others advertise fast trains and ocean liners; the ideal was to travel in style, maintaining one's elegance when sitting in a car or boarding an aeroplane.

What I have written about architecture can also be applied to interior decoration, where one finds a light, unforced balance which does not suggest 'interiors' so much as rooms for living in, rooms with a certain aspiration to style. There is a pleasing sense of under-statement about them; and at the same time a degree of practical, well-designed comfort is never lacking. The dominant characteristic is a sort of hygienic elegance, both in the style of the furniture and in the choice of materials. It was at that period that most of the tubular steel furniture was designed, which we still know and use with its design unchanged; it reached such a level of perfection that variations were neither necessary nor possible. Its lightness and precision of form, as well as its beauty of material, are ideal expressions of the intense simplicity that the designers were aiming for.

The same is true of the best china, glassware and cutlery of that time. They reveal an almost sensual feeling for the relationship between design and material. The maturity of design displayed by the best of these objects is borne out by the fact that almost all of them—at least those suitable for mass-production—are still produced today. In the years around 1930 we see, almost everywhere, a highly developed feeling for material; hard substances such as steel, glass, china and costly stone were preferred to traditional materials with sentimental associations such as wood, brick and pottery. One cannot imagine anything having ornament added to it during this period: the relationship between design and material had become such a close one that any additional decoration was unthinkable.

The way in which the apparatus of modern life fascinated the designers of the day is very striking. Technology had an unmis-takable influence on architecture, but posters also recaptured in pictorial form something of the energy and formal certainty that one associates with ships, trains and aircraft. This admiration seems to have been total; engineering provided direct models. Their

unambiguous and unquestioned rightness, the accuracy of their detail and the hard precision of their materials exercised a fascination over designers and stimulated them. When such an influence was present, it was overtly acknowledged on a basis of full equality. Technology was still seen as both a related speciality and a competitor which must be as concerned with creating an image of its own as any other discipline. From 1935 on—at the latest—this relationship was destroyed by the advent of streamlining, which was both functional and misleading at one and the same time.

It is surely possible to detect an élitism in many of the things created around 1930, a degree of perfection which seems almost merciless. They hold a fascination for us, not least because at times their outlines show an excessive acerbity. Originally, before the passage of time made possible a certain detachment, this fascination may have included an element of intimidation. Even if this feeling was never expressed, it must have existed in a latent form. The flawless manner in which some problems of design were resolved may have created such an impression of finality that any approach seemed barred. The fact that they were also devoid of all emotion made it even more difficult to respond to them.

The twenties were distinguished at first by expressionism and later by a generalized revolutionary ferment. Following this, around 1930, there was a sudden emotional lull, which could be interpreted not only as a sign of reflection and maturity but also as an ominous elimination of all expression of feeling. It may have been the fear of an apparently soulless future that blinded many people to the real value of the things around them.

Perhaps, when they were made, the design of all the things illustrated in this book was too perfect, involving too much ideal vision and too little credible reality. I need not labour the point that this was the antithesis of the everyday experience of the period. The self-evident rightness that it possessed in itself could be accepted by the public only in small instalments. Because it was

not petit-bourgeois, this style was alien to most people, and because it was for intended them it aroused their mistrust. In 1930 utopia started to become reality, but was scorned because the fantasy of the unattainable seemed far more comfortable than the reality of the concrete. This is a phenomenon which recurs disconcertingly often.

The precision we have already noticed in the objects themselves finds its counterpart in the manner in which they were observed. Thus, in the years around 1930, the view of buildings, people or inanimate objects through the medium of photography reveals the same dispassionate precision. Restraint, calm and laconicism pervade the photographs, enabling them to achieve a feeling of space, silence and clarity. They are not anecdotal, and they steer clear of narrative. The emotionalism still widespread in the twenties has given way to a greater reserve. The observer is no longer assaulted by the direct impact of the motif. Experiments in style had prevailed earlier: multiple exposure, shots taken from unusual angles, photography without a camera (achieved by placing objects between the light source and the plate). These experiments have been replaced by a cool exactitude, allowing one to sense not emotion but a balanced awareness. The composition is confined to a few bold accents, while movements or violent gestures are avoided. At the same time the pictures are far removed from that utilitarian, unthinking optimism which reflects a common and persistent misunderstanding of the possibilities of photography. They neither portray nature as idyllic nor reproduce some motif 'from real life' with an artificial complacency.

On the contrary, one is more likely to detect a touch of melancholy, the wary and slightly hesitant air of something not yet quite sure of the permanence of its position. It is probably reasonable to try and see in this a forewarning, however vague, of the approaching catastrophe; yet, like all such conjectures, it is difficult to prove.

That a slight air of resignation hung over the period around 1930 is indeed understandable. It was based on the conflict between stylistic maturity and political and economic catastrophe. In spite of the outward appearance of growing success, there must by then have existed an awareness—caused directly by the situation prevailing in 1930—of the possibly barren future awaiting all progressive activities. The instability and uncertainty of the period had forced this awareness into existence. That the best examples of design should meet a dwindling willingness to accept them invests the period with a tragic air, which is reflected in its photography.

The objects in the photographs are neither impressive nor of particular importance: indeed, they seem to have been chosen quite casually. But the calm and sensitive way in which they are captured by the camera of Alfred Renger-Patzsch, say, or Walter Peterhans, endows them with a certain unreal grandeur. This lifts the image above the banality of the subject-matter and moves it into a world of mystery and reticence. Their detached precision creates a spaciousness and allows scope for imaginative reflection. This richness of suggestion is astonishing, its effect all the greater the more casual and uncontrived the subject-matter. The street scenes of Renger-Patzsch suggest in their detachment greater authenticity and urgency than would some conventional descriptive scene, however realistic it was intented to be. They show a working-class district, quite concisely, without rhetoric and with an almost excessive restraint; the effect is honest and full of reasoned sympathy.

The spell cast by these pictures was evidently so compelling in its own day that it also influenced photographers who otherwise practised a narrative style of reportage. This is true of both Brassai and Henri Cartier-Bresson, some of whose photographs achieve a more-than-real reality. The 'surreal' school lived on in North America, where it began to assert itself from the mid-thirties onwards—as did modern architecture. A governmental commission

to make photographic records of the desolation of the Dust Bowl gave photographers like Walter Evans, Edward Weston and Dorothea Lange the chance to capture a dead world in beautiful pictures.

The same concision and detachment is present both in photographs of objects and people. The portraits of Man Ray and Herbert List are an example of this. Nothing appears in them direct, yet everything has the clarity of a waking dream. This approach combines detachment with intensity.

There are also examples in which microscopic precision gives rise to an almost painful sharpness. Restraint now gives way to a greater directness, although detachment still remains; and the result seems almost a parody. The photographs avoid the pathetic fallacy and show that precision can also be amusing. This is particularly true of Herbert Bayer and—in one special instance—of René Clair, who, in his film 'A nous la liberté', treated an austere architecture in a witty manner.

In general a characteristic of photography at the beginning of the thirties was an affinity with its subject-matter—this is particularly true of inanimate objects, but less so of people. This is reflected as much in the concise sobriety of commercial photography as in the almost over-refined sensuality of the fashion plates—and in everything related to them. Even more than the beautiful yet austere photographs by Beaton, Steichen and Hoyningen-Huené, the motion pictures recapture something of the artists' almost fetish-like relationship with their materials—which for the most part were expensive. A subtle, but never obvious, sensuality emerged from the visual world of art that was created by Hollywood. Veiled nuances, and the refinements of contrived lighting, by themselves were enough to create an entirely new universe. The peak of this esoteric development—which seems to have taken place in complete isolation—is reached in the films which Josef von Sternberg shot between 1930 and 1935 with Marlene Dietrich. In these films

inanimate and animate objects alike were of an equal, unique beauty. The sensitivity in the photographic treatment of original décors could also be seen clearly in the musicals and costume pictures made in that period. All this brilliance was not wasted; the film-makers could count on an audience whose visual sensitivity was equal to their own.

If there is an additional criterion for assessing the art and design of a period, it is that of its social effectiveness. The level of general understanding and recognition gained by the creative works of any period can be assessed only by examining their distribution through private and public life. In doing this we should take into account not only the standard of the individual item, but also that of things in more or less general use.

There is a clear justification for pointing to an increasing dissemination of modern, practical design around 1930. In contrast to the twenties, when an atmosphere of spirited conflict still prevailed, ideas which had previously been contested came gradually to seem less shocking. This is particularly noticeable in the simple, unspectacular objects in general use, where the designers, by exercising greater restraint, had succeeded in overcoming the initial rejection of their work. This suggests two things: first, that the creative vocabulary of 1930 was no longer restricted to design intended for an élite; and second, that there was now a wider demand. Much of the design illustrated in this book could not have been created without the sympathetic support of public bodies. This is true of the splendid exhibitions of that time, as well as of the extensive housing projects and of the equipment put in them. For at this stage, when such things as railway stations, post offices, sports stadia and hospitals were also entering the sphere of modern design, it is reasonable to speak of public acceptance. Yet it is difficult today to point to any evidence of this. Much can no longer be traced, because it has remained anonymous—as it was originally intended to

be. Its identification is purely a matter of chance. Other things, after the lapse of time, are difficult to reproduce effectively in photographs. The various streetcars and railway carriages, small cars, hospital fittings, cheap prefabricated furniture, lamps and simple utensils, which were well designed—and which in the intervening years have worn out—can today only be shown in a few photographs or not at all. They were apparently taken so much for granted in their day that they were not considered worthy of a careful photographic record. We are therefore thrown back on the record provided by architecture and by such objects of industrial mass production as have continued to be manufactured to the present day.

A further restriction of choice occurred because there were only a certain number of European countries where anyone really wanted to produce modern design. The countries which showed themselves the most receptive to modern trends were those which had undergone a fundamental social upheaval as a result of the First World War, and for which the solution of special problems was of particular urgency. This was particularly true of German and Austria. But it also applied to countries which had always had a more fluid internal social structure, where traditions were not so oppressive —such as, for example, Holland, Switzerland, Czechoslovakia and Scandinavia. In Russia also, for a time, a somewhat strained attempt was made to join in the modern movement. By contrast, in France the interest in modern design was limited to individual patrons, in Italy it remained ambivalent, and in the English-speaking countries it had as yet hardly been awakened.

In Germany, progressive ventures were concentrated mainly in two cities, Berlin and Frankfurt. In this respect Berlin had the advantage of being the capital. The case of Frankfurt, on the other hand, was unexpected, in that the town had a reputation for philistinism. It owed its progressiveness very largely to its City Architect, Ernst May, who succeeded in collecting round him many powerful allies.

It was on his initiave that 'Das neue Frankfurt' also came into being. It was an excellent magazine which from 1927 to 1923 reported on all aspects of applied design, from architecture, theatre and cinema to communications. Together with the organ of the Deutscher Werkbund, 'Die Form', it provided the best general survey of the various progressive trends of that period.

Of all the objects which these magazines illustrated, it is remarkable how few display that oversweet, false simplicity which designers tend to think of as satisfying the aspirations of the petit-bourgeois. The artists refrained from treating poverty as some kind of heaven-sent opportunity to live with pretty, simple things. On the contrary, they directed their art at an adult public, conscious of its own aspirations. They did not want to create a proletarian fairyland governed by well-meaning condescension, but tried instead to create useful things for a world of free people, able to exercise their own choice. The furniture illustrated in this book—by Aalto, Gropius, Moser and others—is evidence of this, as is the china and glass of Gretsch and Wagenfeld. Their simplicity is meaningful and planned, and they possess a timeless validity. They are cheap without seeming to be so; their actual value is greater than their price.

It was during this period that, in numerous exhibitions, an attempt was made to popularize the products of good design. In Germany, Scandinavia and Switzerland, in particular, there was no lack of support. For the first time model dwellings were furnished, in order to show the unforced practicality of the new furniture. It is true that this was sometimes done in a clumsy fashion and with an unnecessary meanness; and the underlying educational purpose was shown with a clarity which was not free from prejudice. That, however, did not detract from the merit of the individual works.

Social consciousness and an awareness of good design are particularly noticeable in the numerous large housing estates built at that time by the more thoughtful German local authorities. To this

day they remain the clearest evidence of the best aspirations of their time. In contrast to the concentric ring development general in the twenties, now it was the turn of an open linear layout, with separate houses arranged in parallel rows which could be linked together by green zones. In particular Walter Gropius contributed some highly advanced designs. In this way the massive, generally rather fortress-like appearance of the buildings in the older housing estates was abandoned in favour of an elegant, extended pattern whose regularity represents a clearly co-ordinated conception of urban planning. The freedom of orientation achieved by this open building method may almost be taken as the ideal of the period which had created it. It contained many possibilities for developing a new life pattern—as well as the possibility of the fearful shipwreck that lay ahead.

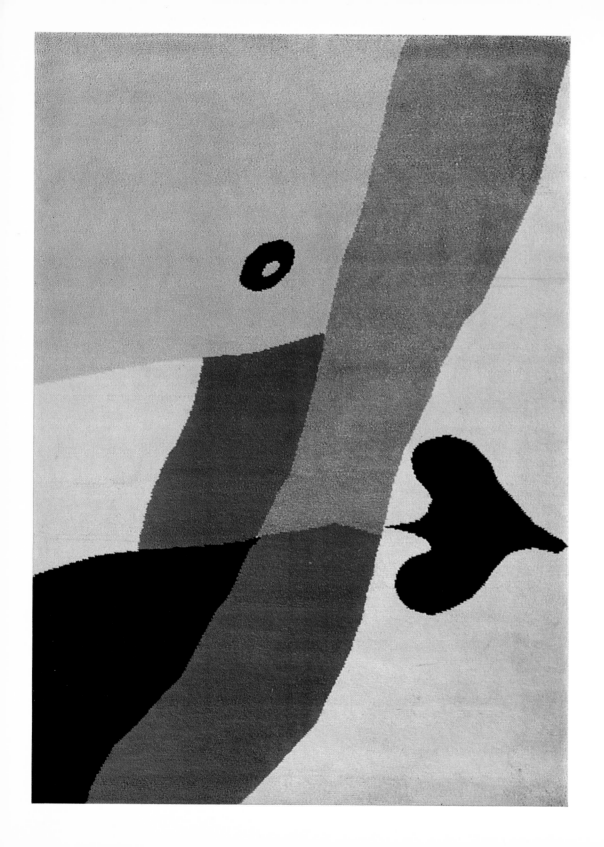

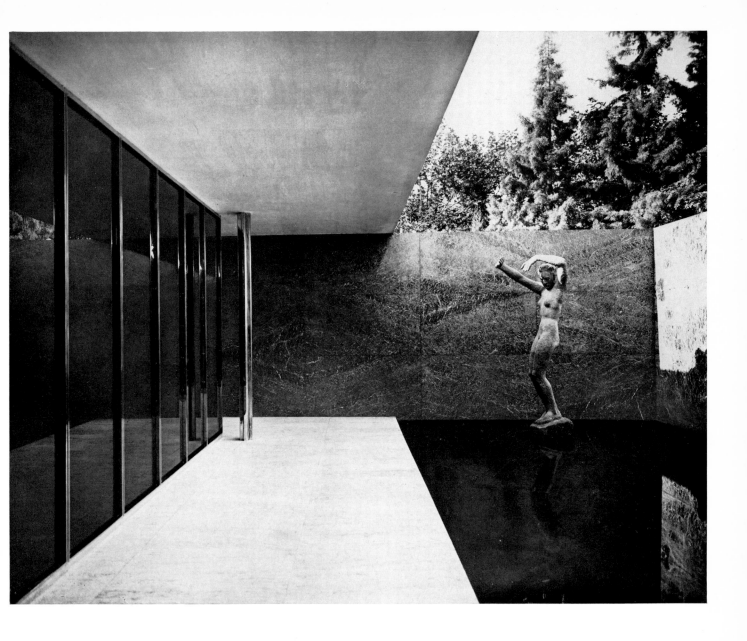

I
Hans Arp
Ace of Spades tapestry, 1930

1
Ludwig Mies van der Rohe
German Pavilion at the International
Exhibition in Barcelona, 1929

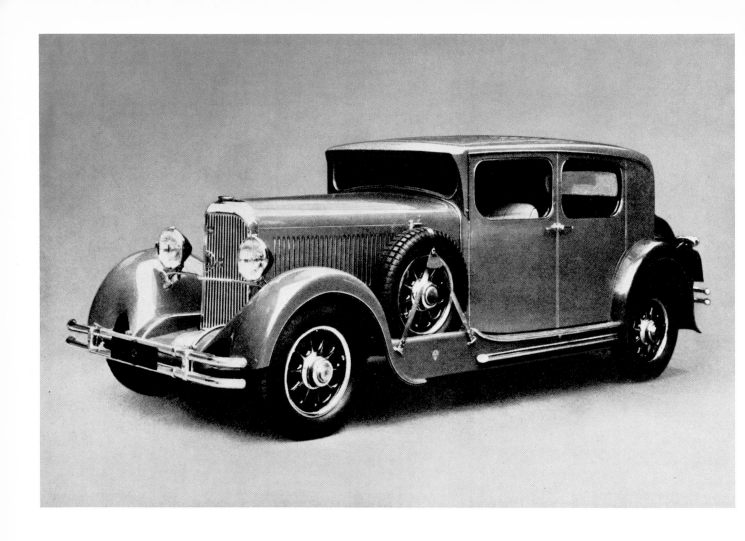

2
Million-Guiet
Coachwork of Panhard-Levassor motor-car,
France, c. 1930

3
George Hoyningen-Huené
Fashion photograph for 'Vogue', Paris, 1934

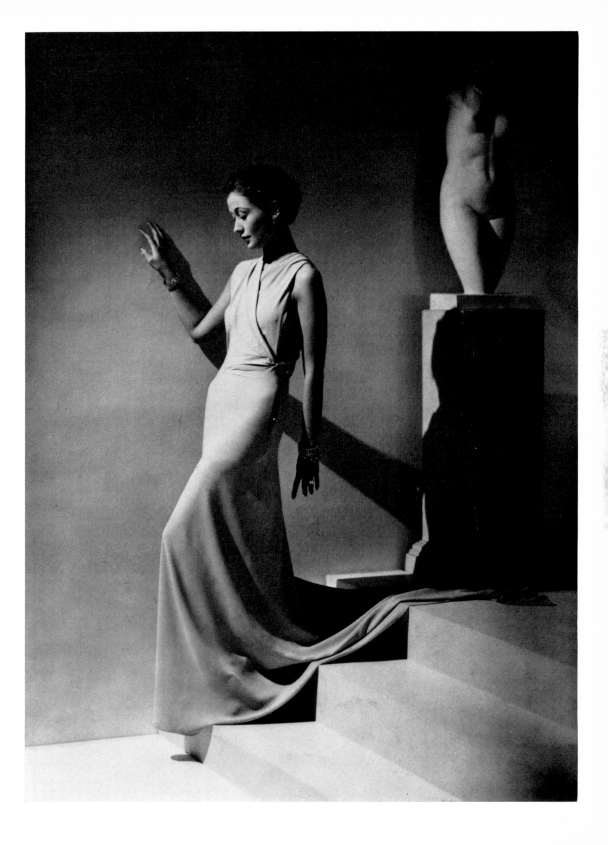

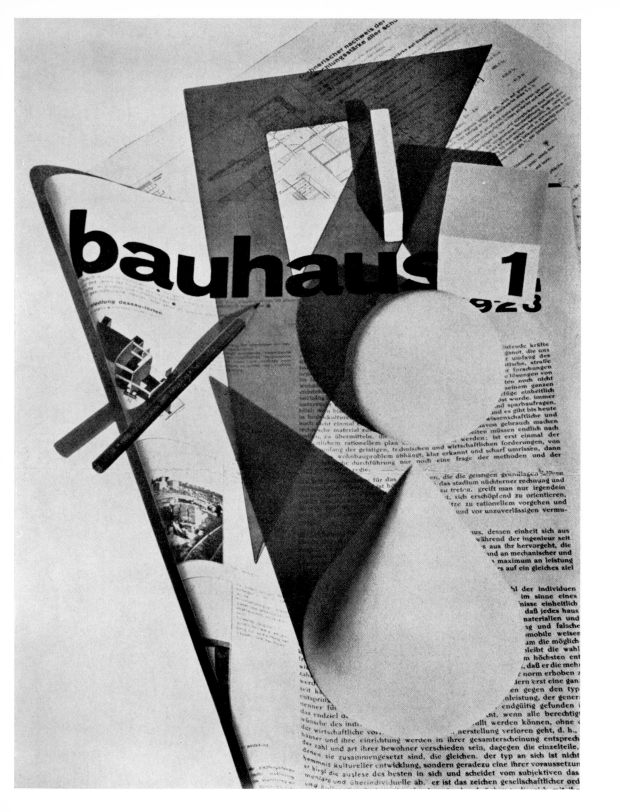

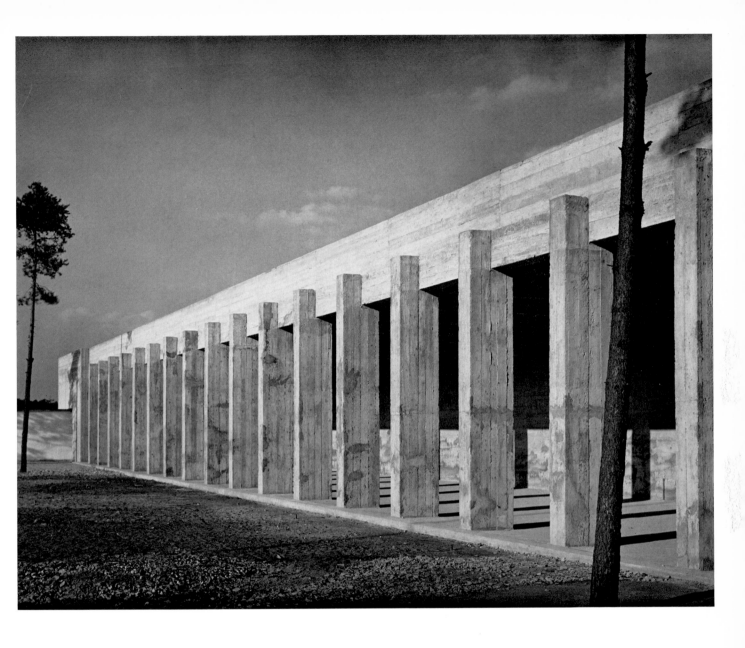

4
Herbert Bayer
Title-Page of the magazine 'bauhaus', 1928

5
Otto Ernst Schweizer
Nuremberg Stadium, 1928

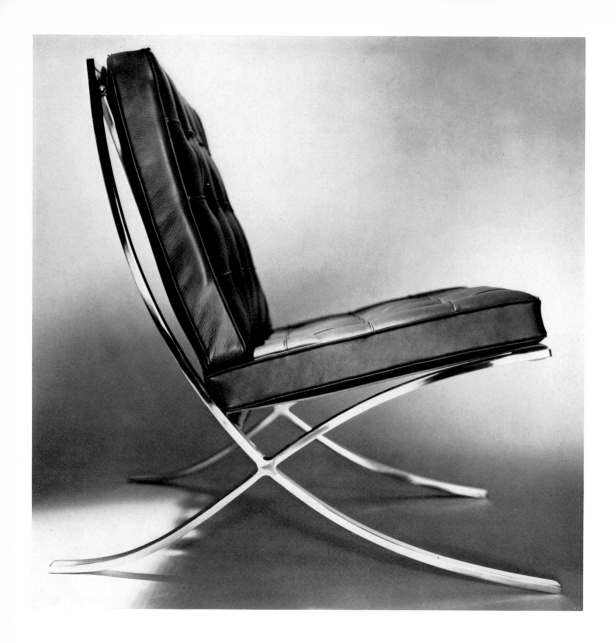

6
Ludwig Mies van der Rohe
Chair, 1929

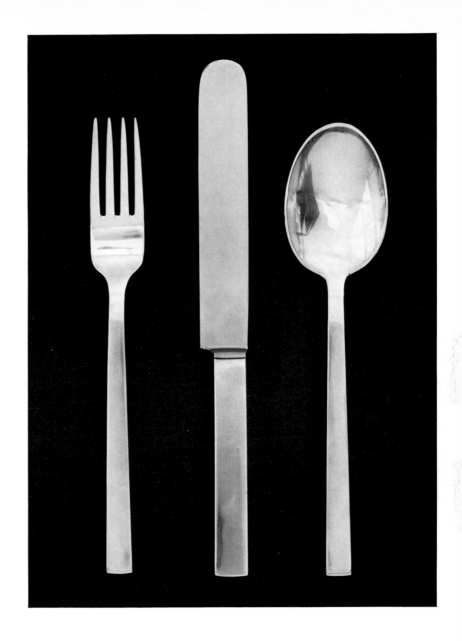

7
Andreas Moritz
Handwrought silver cutlery, 1928

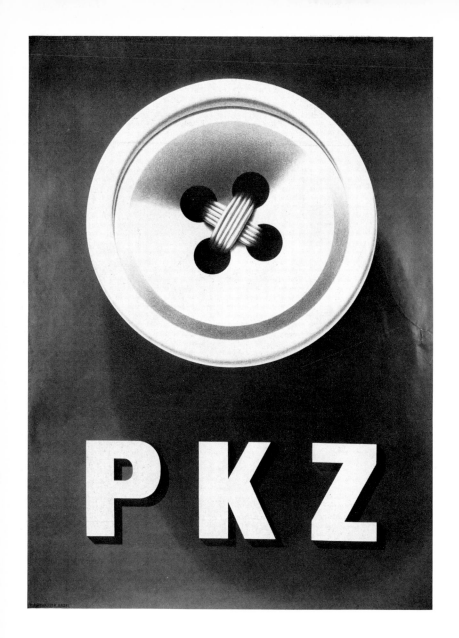

8
Peter Birkhäuser
Poster for the fashion house PKZ, Zürich, 1934

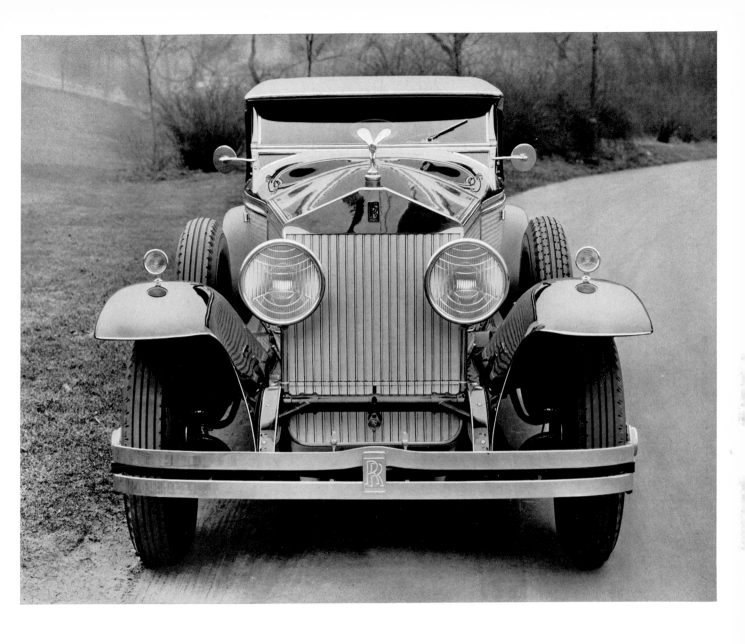

9
Rolls-Royce, England
Springfield Phantom I motor-car, 1929

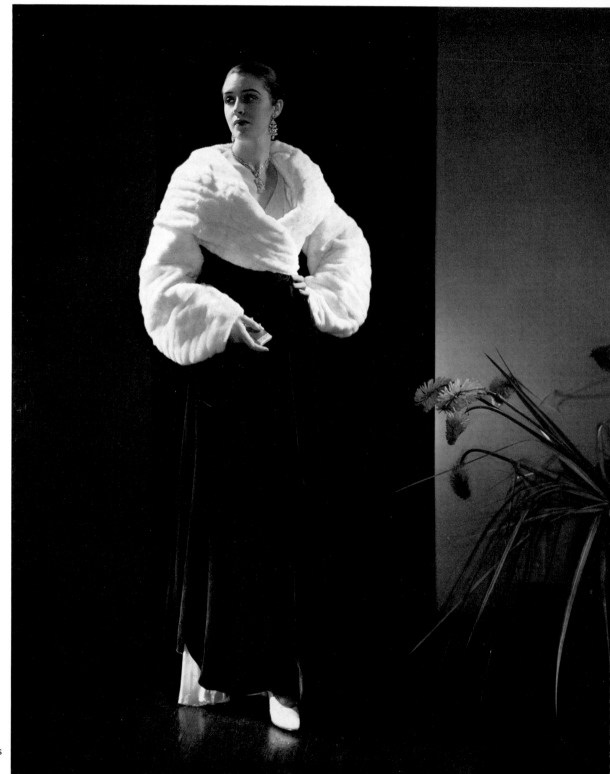

10–11
Edward Steichen
Fashion photographs
for 'Vogue', 1930

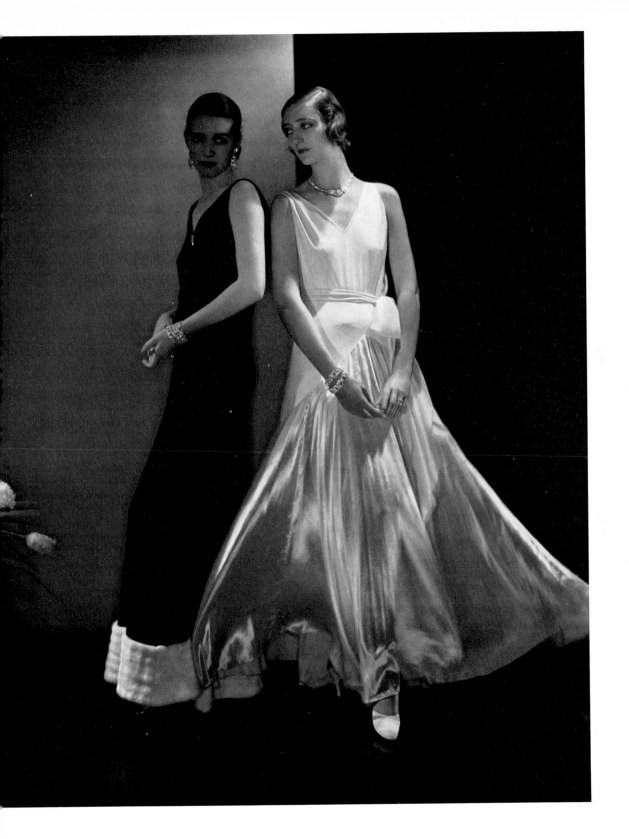

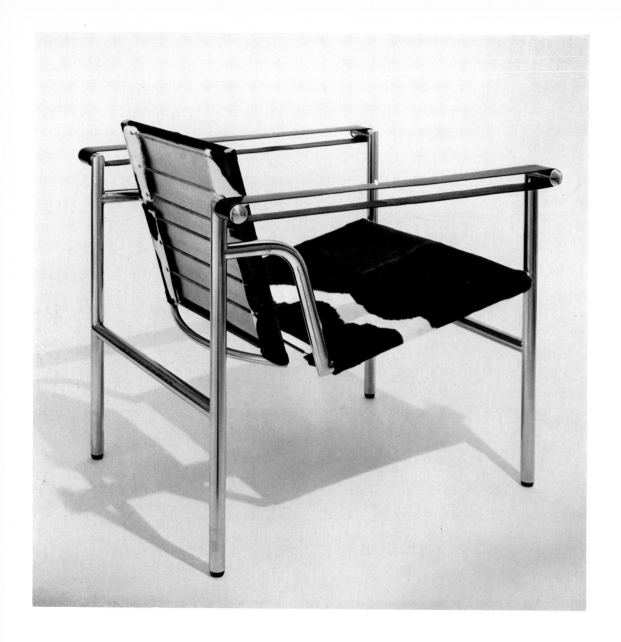

12
Le Corbusier and Charlotte Perriand
Chair with adjustable back, Paris, 1929

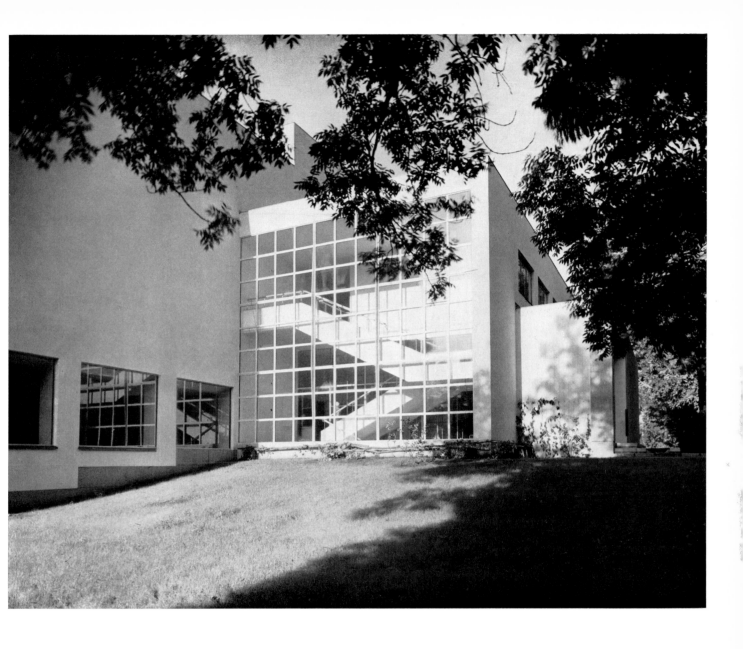

13
Alvar Aalto
Library, Viipuri, Finland, 1927

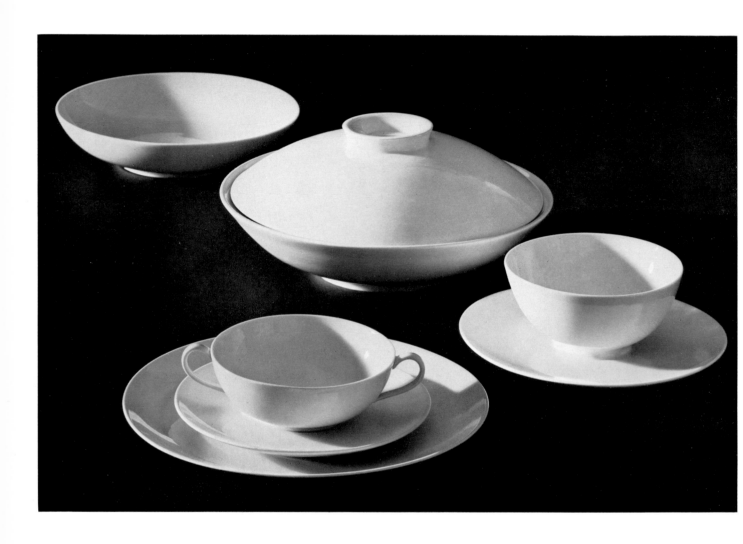

14
Trude Petri
Urbino china dinner-service, 1930

15
Max Bill
Poster for an exhibition
of primitive art, Zürich, 1931

negerkunst

prähistorische
 felsbilder südafrikas

kunstgewerbemuseum zürich

ausstellung 2.—30. august 1931

geöffnet 10—12 14—18 uhr

sonntag —17 uhr

montag geschlossen

eintritt —.50

nachmittag und sonntag frei

entwurf: bill-zürich druck: buchdruck-zürich

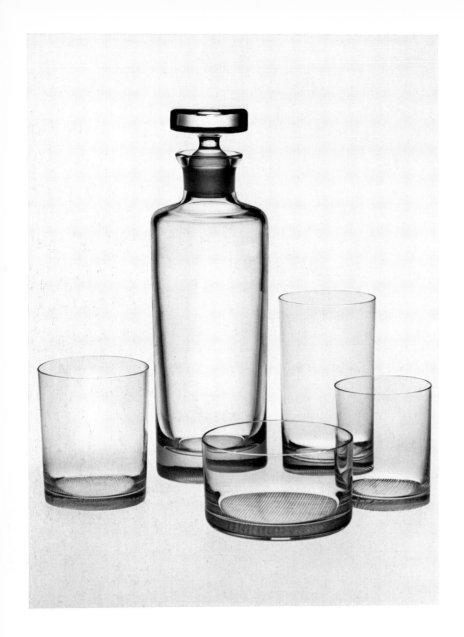

16
Adolf Loos
Set of glassware, 1933

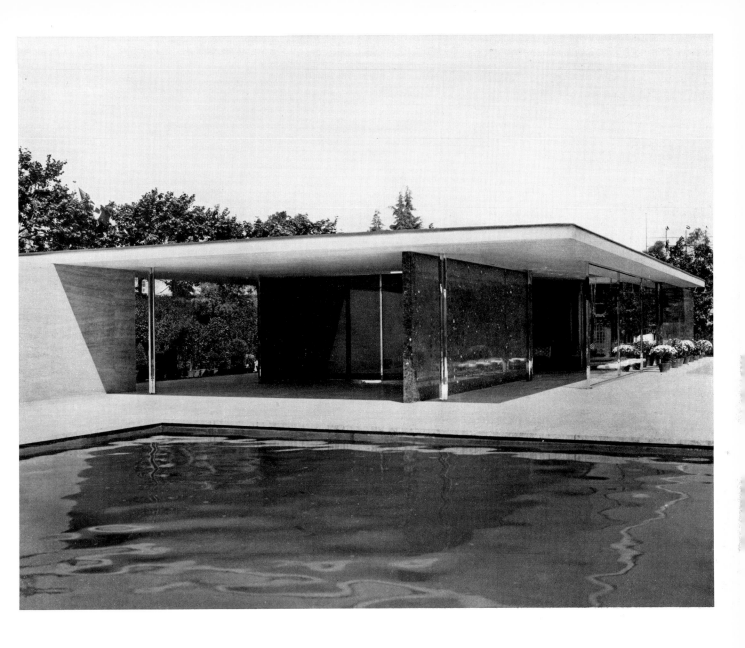

17
Ludwig Mies van der Rohe
German Pavilion at the International
Exhibition in Barcelona, 1929

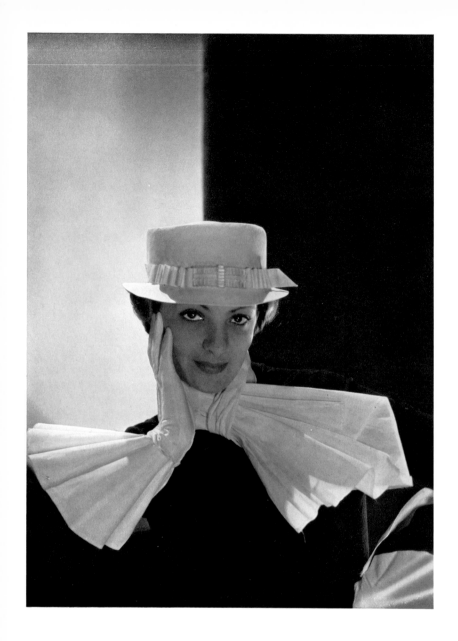

18
George Hoyningen-Huené
Fashion photograph for 'Vogue', 1933

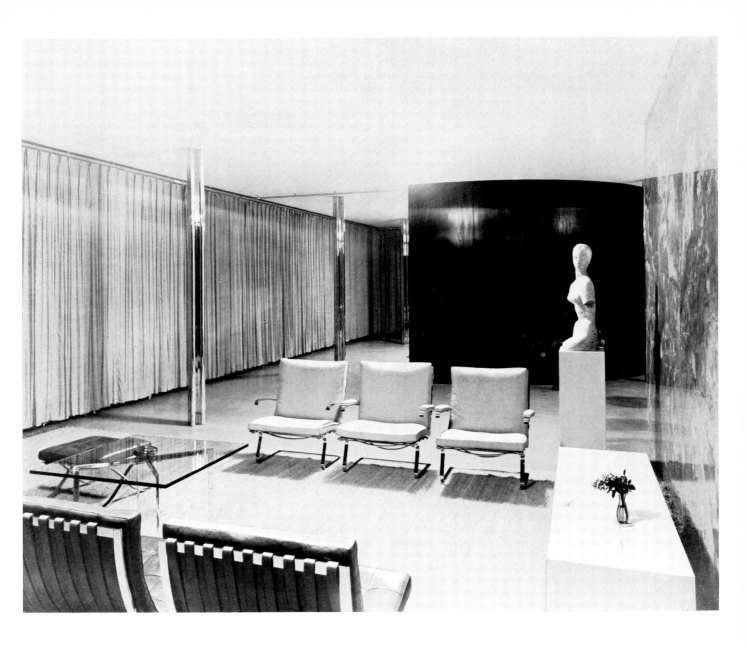

19
Ludwig Mies van der Rohe
Tugendhat House, Brno, 1930

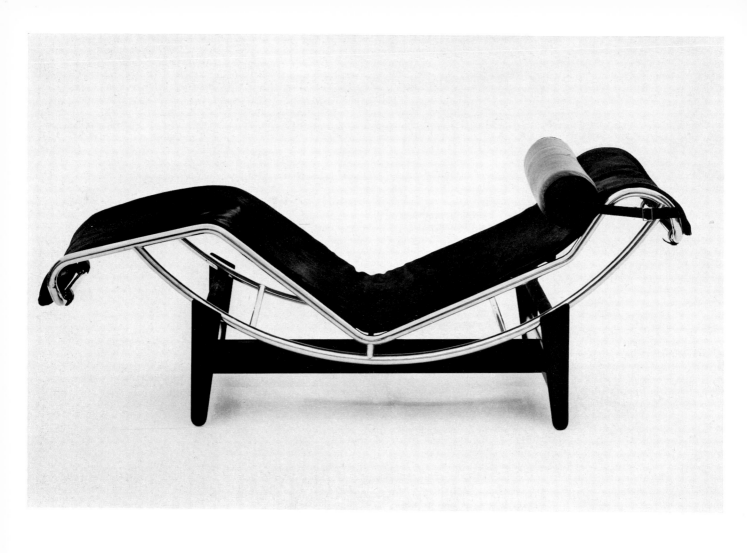

20
Le Corbusier and Charlotte Perriand
Adjustable couch, Paris, 1929

21
Giuseppe Terragni
People's palace, Como, 1932

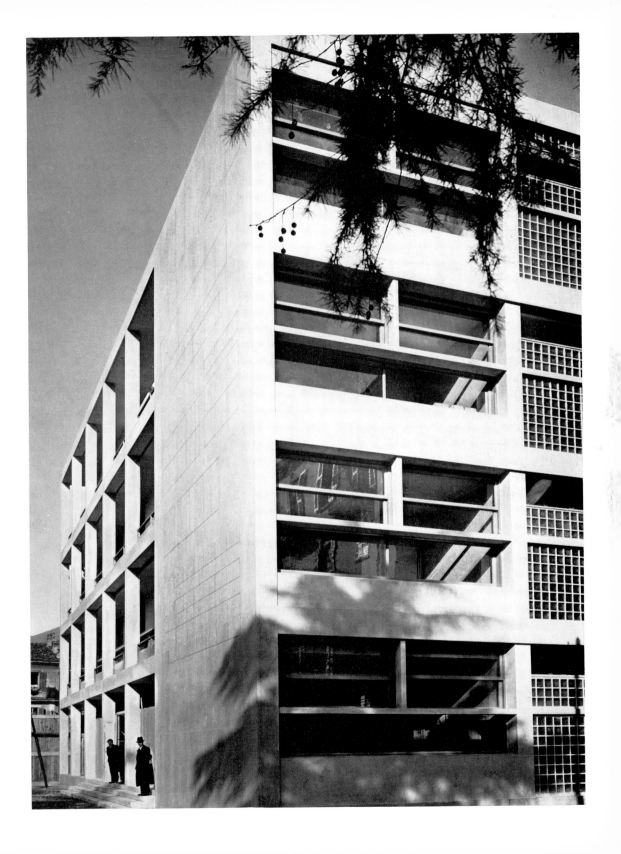

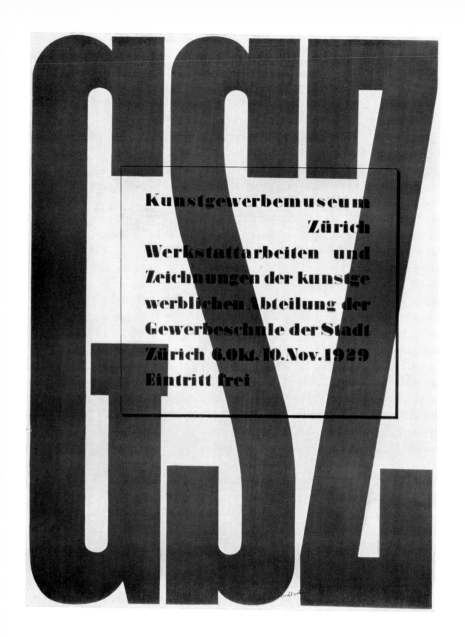

22
Hans Aeschbach
Poster for an arts and crafts students'
exhibition, Zürich, 1929

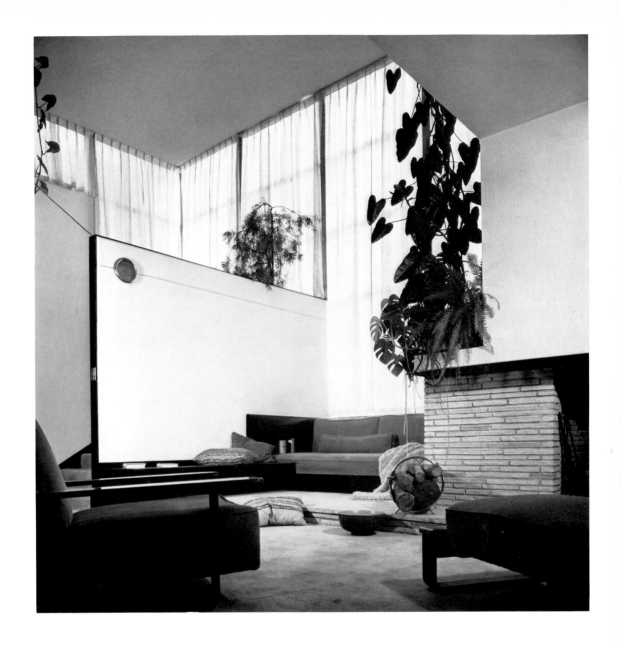

23
Richard Neutra
Health House, Los Angeles, 1928

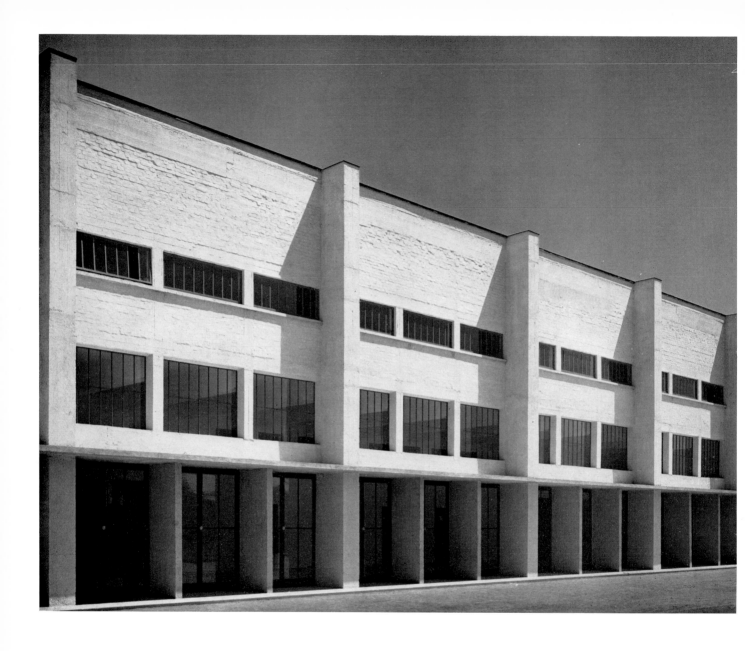

24
Otto Ernst Schweizer
Nuremberg Stadium, 1928

II
Pierre Masseau
Poster for French state railways, 1931

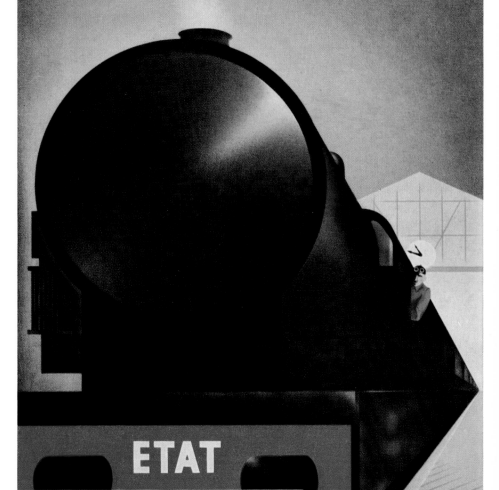

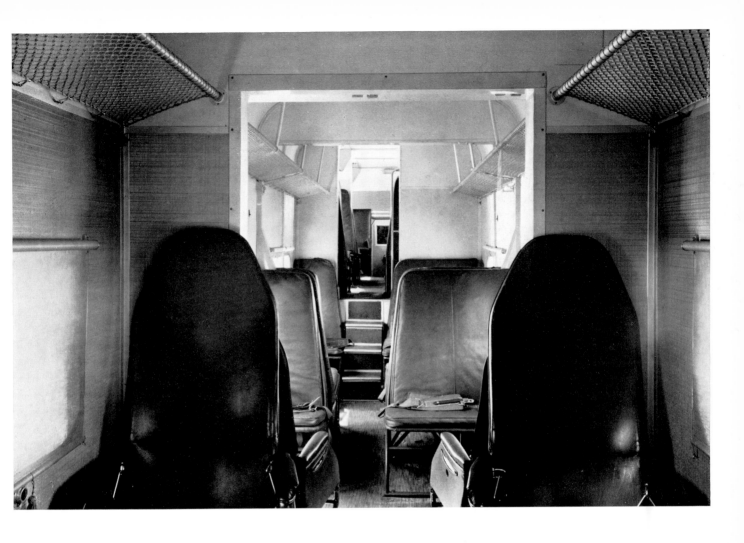

25
Junkers Flugzeugwerke, Germany
Passenger cabin of G 38 airliner, 1929

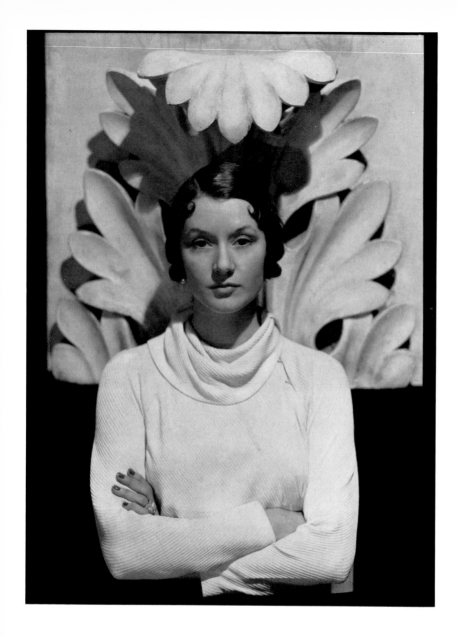

26
George Hoyningen-Huené
Fashion photograph for 'Vogue', 1932

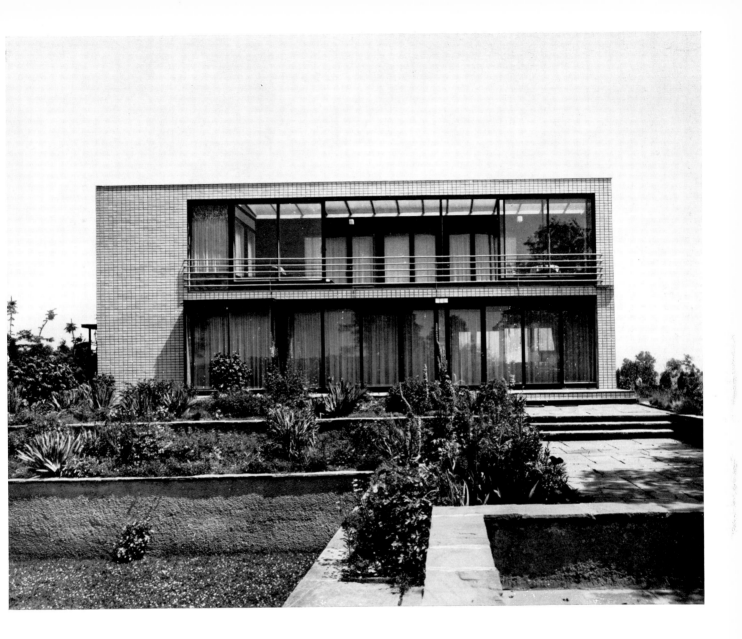

27
Wassili and Hans Luckhardt
House, Velten, near Berlin, 1932

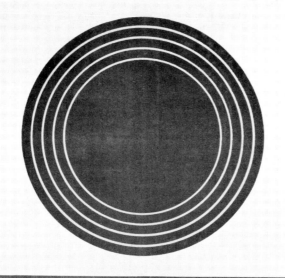

OSTSEE·JAHR 1931

KÖNIGSBERG · ZOPPOT / FREIE STADT DANZIG
GREIFSWALD · STRALSUND · ROSTOCK · LÜBECK
KIEL · SCHLESWIG · FLENSBURG · KOPENHAGEN
DÄNEMARK · SCHWEDEN · FINNLAND
DIE OSTSEEBÄDER: MEMELGEBIET · CRANZ · KOLBERG
MISDROY · SWINEMÜNDE · HERINGSDORF · BINZ / RÜGEN
WUSTROW · WARNEMÜNDE · BRUNSHAUPTEN · TRAVEMÜNDE
GROSSKURGEBIET · LÜBECKER · BUCHT · KIELER FÖRDE

REISEN SIE 1931
AN DIE OSTSEE
ÜBER DIE OSTSEE

SONDERVERANSTALTUNGEN IN ALLEN BETEILIGTEN
STÄDTEN UND BÄDERN WÄHREND DES GANZEN SOMMERS 1931
ERÖFFNUNG DES OSTSEEJAHRES AM HIMMELFAHRTSTAGE
DEM 14. MAI 1931 IN LÜBECK.

A MAHLAU
DRUCK VON H. G. RAHTGENS G. M. B. H. LÜBECK

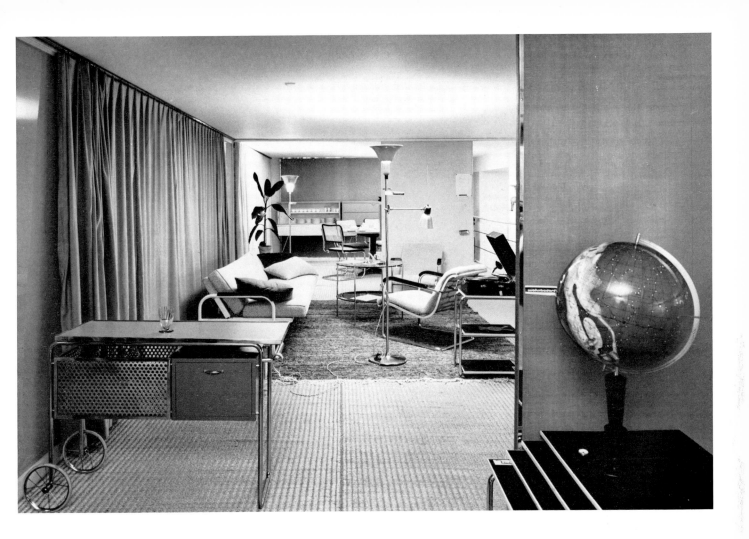

28
Alfred Mahlau
Travel poster, Lübeck, 1931

29
Marcel Breuer
Wohnbedarf furniture store, Zürich, 1933

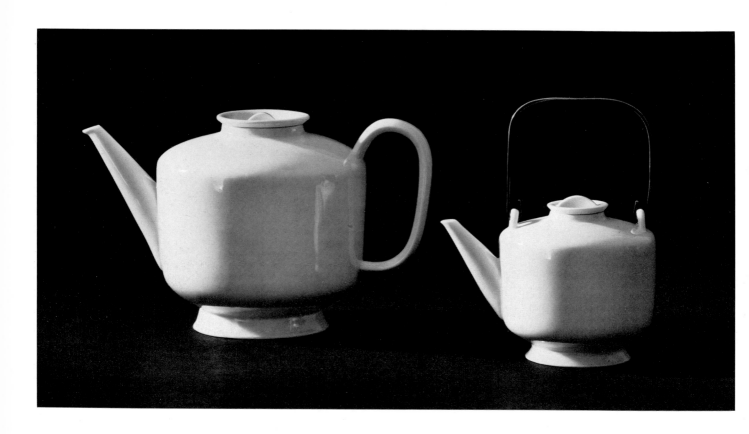

30
Marguerite Friedlaender
Two china teapots, 1930

31
Rudolf Schwarz, with Hans Schwippert
and Johannes Krahn
Fronleichnamskirche, Aachen, 1930

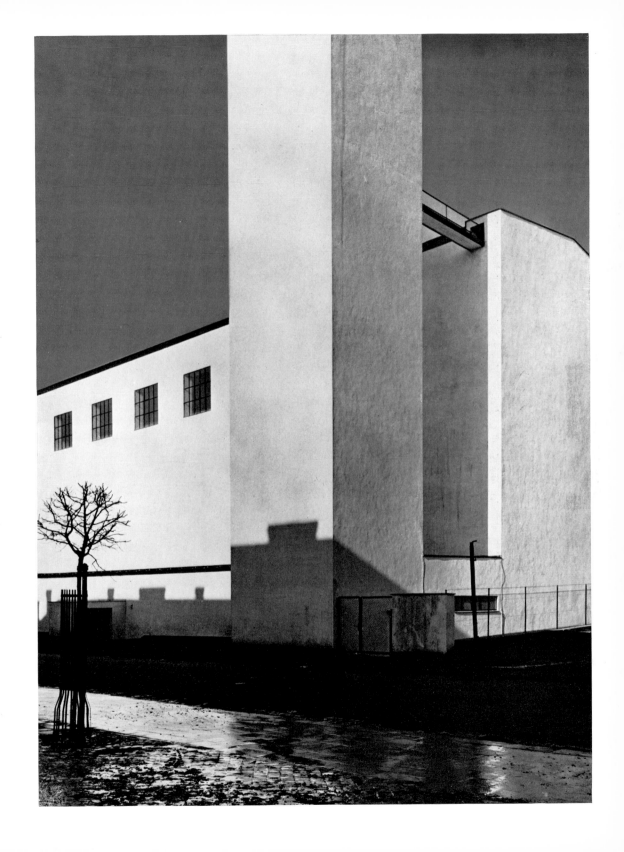

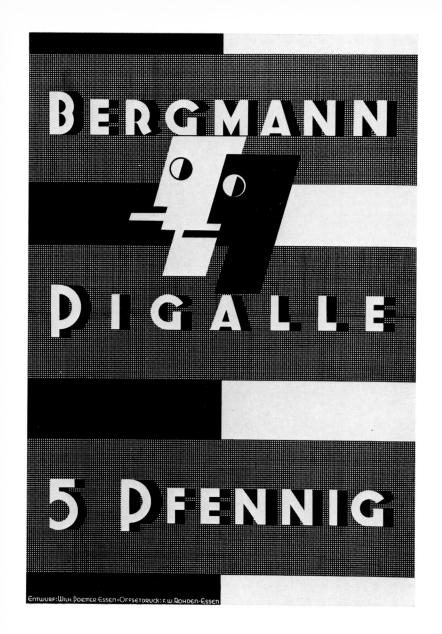

32
Wilhelm Poetter
Cigarette poster, Essen, 1929

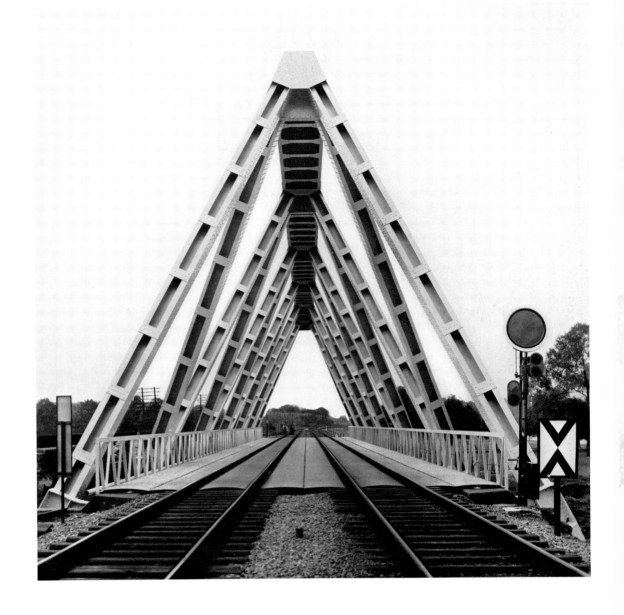

33
German state railways, design
department, Cologne
Two-track railway bridge over
the Ruhr near Düren, 1929

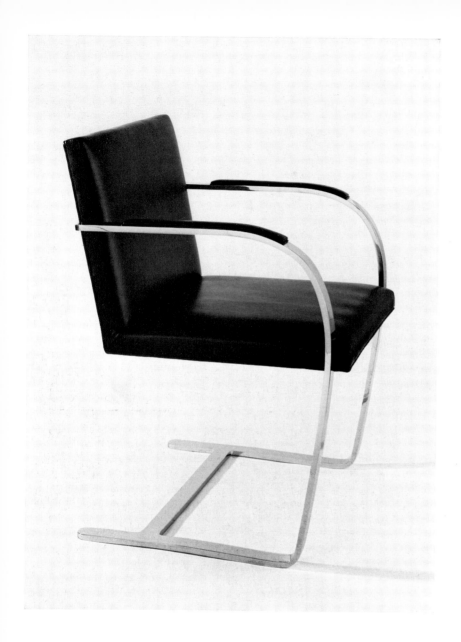

34
Ludwig Mies van der Rohe
Chair, 1930

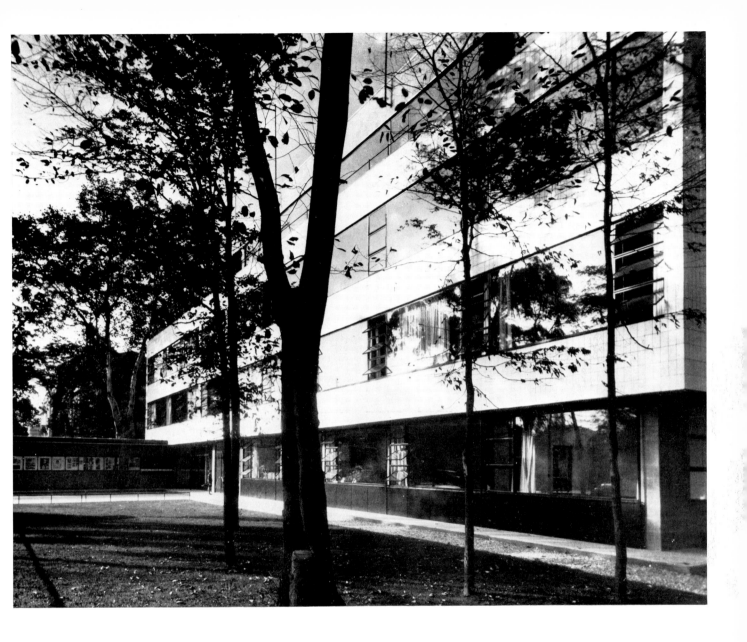

35
J. W. Lehr
Offices for the journal 'Volksstimme', Frankfurt, 1929

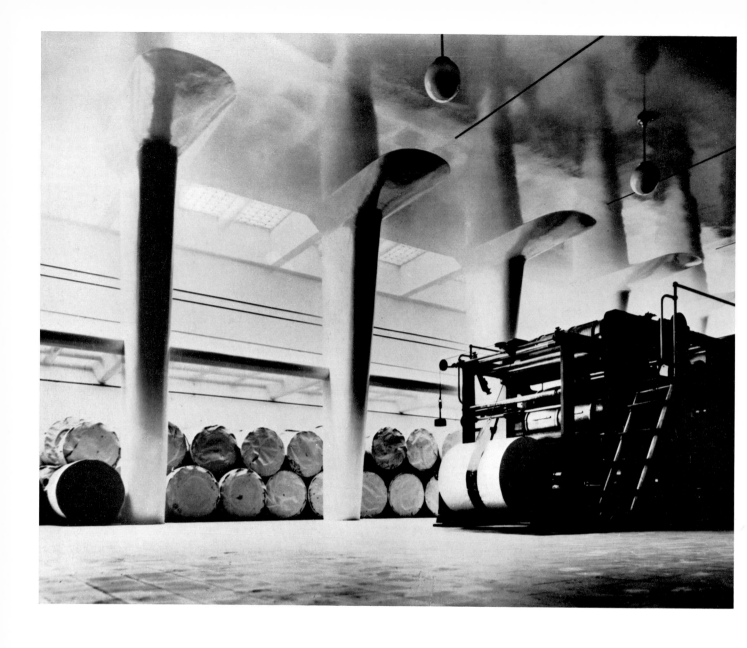

36
Alvar Aalto
Printing-house for the journal 'Turun Sanomat',
Turku, Finland, 1927

III
A. M. Cassandre
Poster for an electrical firm, Paris, 1931

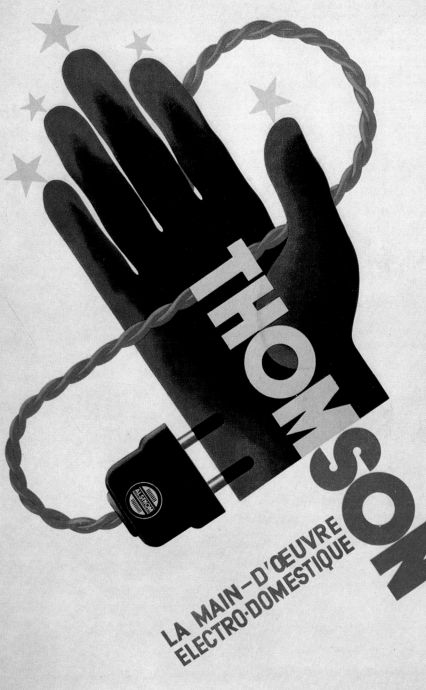

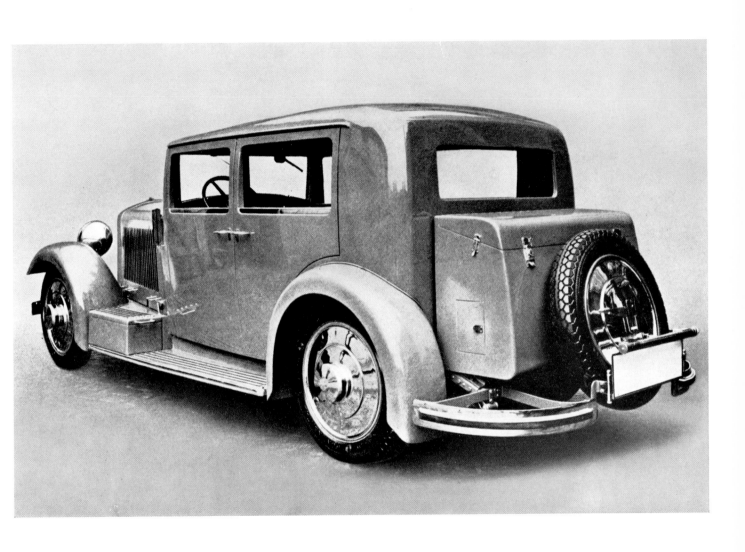

37
Walter Gropius
Coachwork of Adler motor-car, Germany, 1930

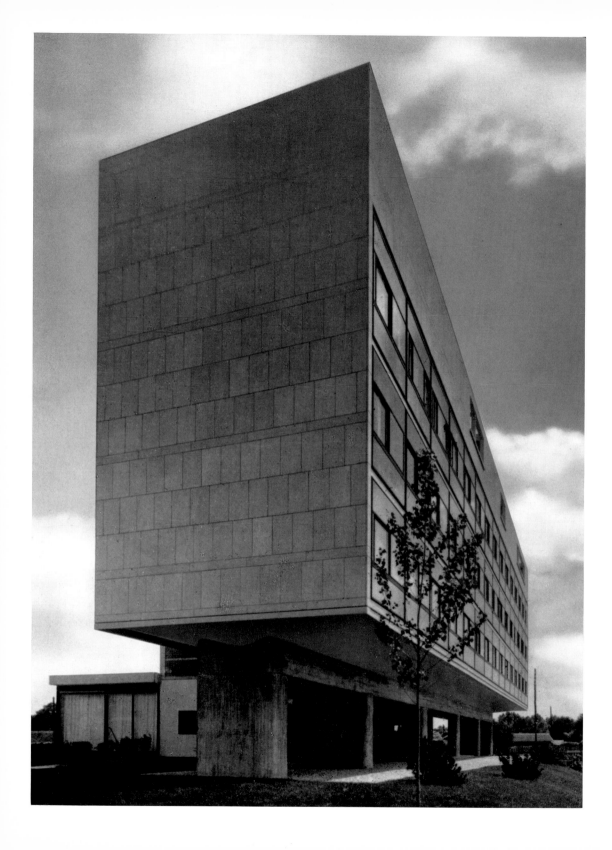

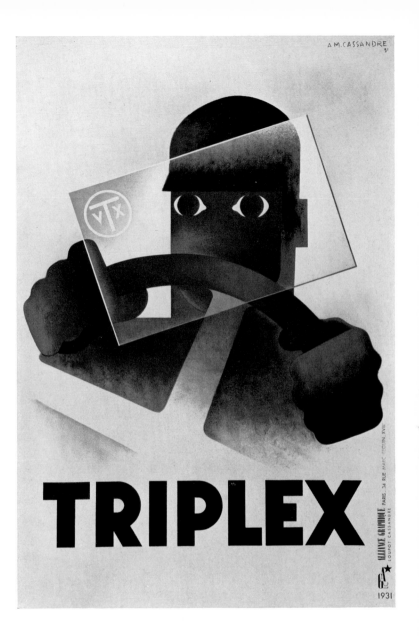

38
Le Corbusier and Pierre Jeanneret
Swiss student hostel in the Cité Universitaire,
Paris, 1930

39
A. M. Cassandre
Poster for safety glass, 1931

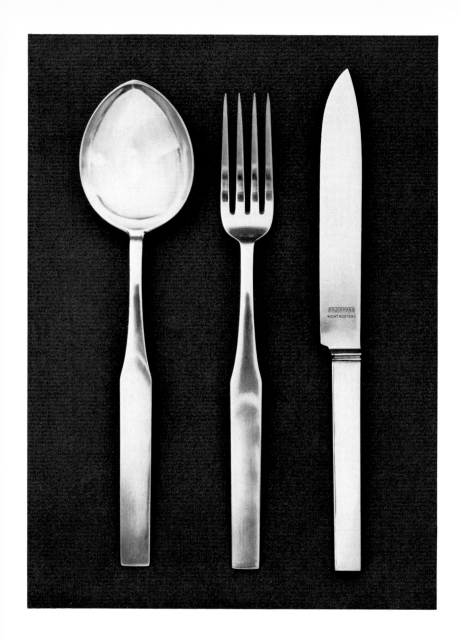

40
Emil Lettré
Silver cutlery, 1932

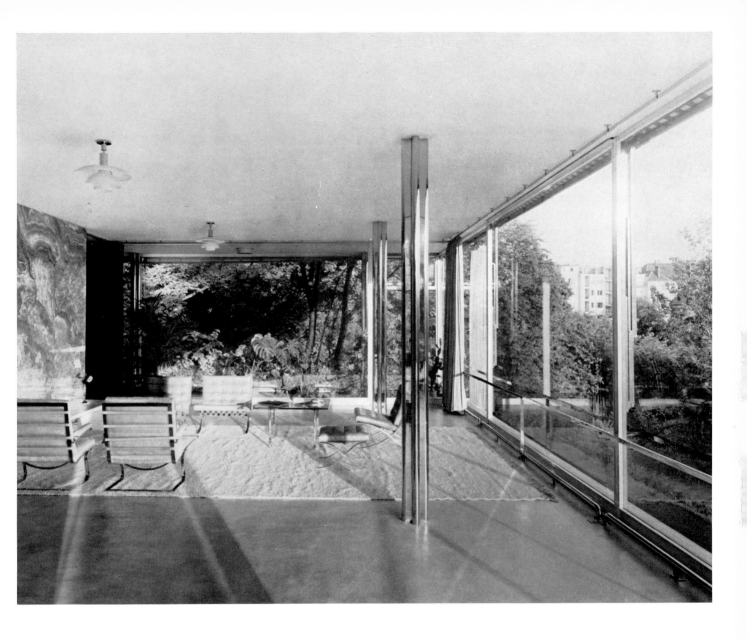

41
Ludwig Mies van der Rohe
Tugendhat House, Brno, 1930

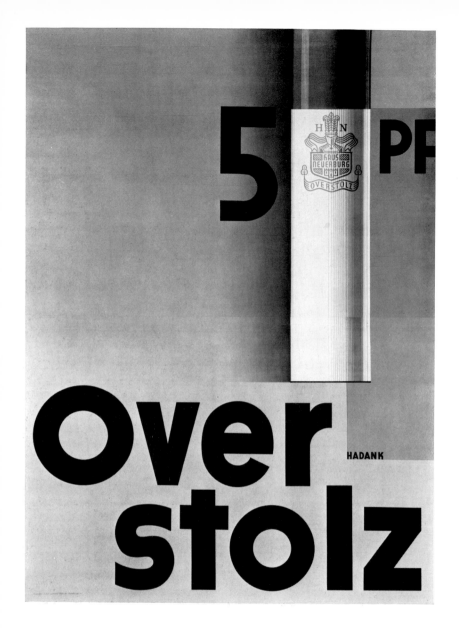

42
O. H. W. Hadank
Cigarette Poster, Germany, c. 1930

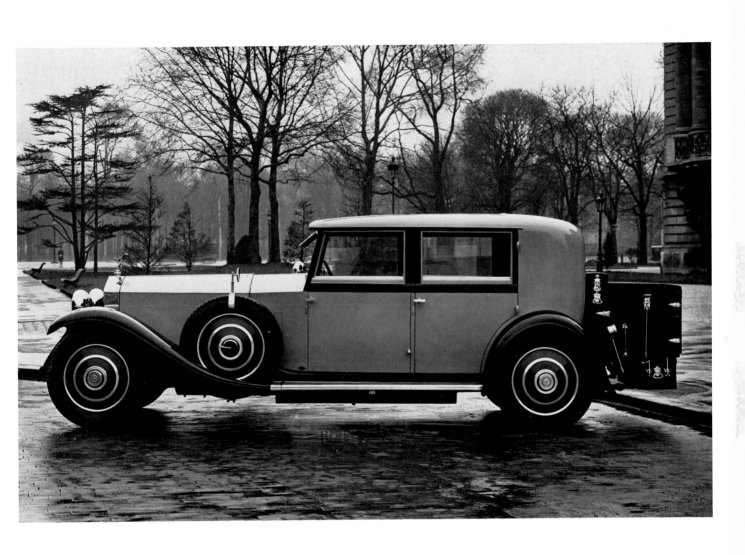

43
Henry Binder
Coachwork of Rolls-Royce Phantom II motor-car, 1929

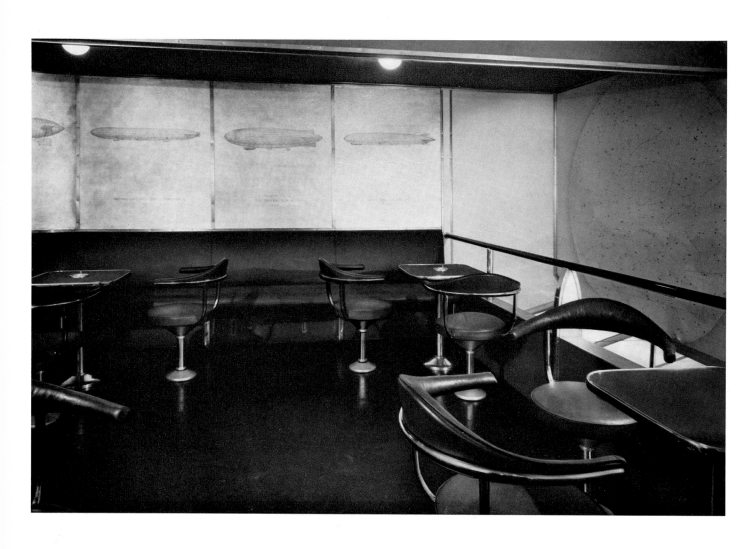

44
Fritz August Breuhaus de Groot
Smoking-room in the airship 'LZ 129 (Hindenburg)'

45
Herbert Bayer
Title-page of the magazine 'die neue linie',
Berlin, 1931

die neue linie

juni 1931

heft 10 juni 1931 preis 1 mark verlag otto beyer leipzig / berlin

herbert bayer dorland

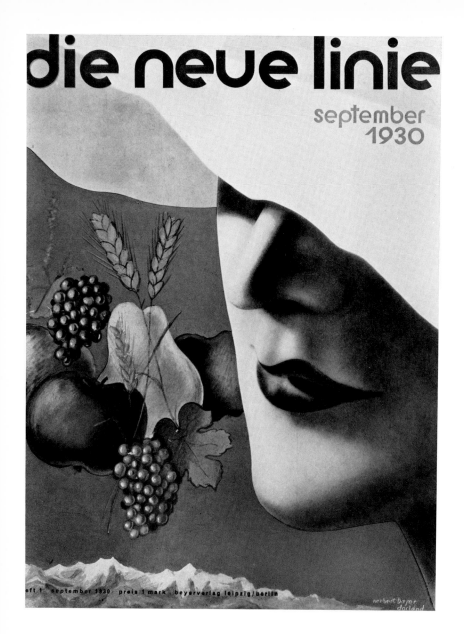

46
Herbert Bayer
Title-page of the magazine 'die neue linie',
Berlin, 1930

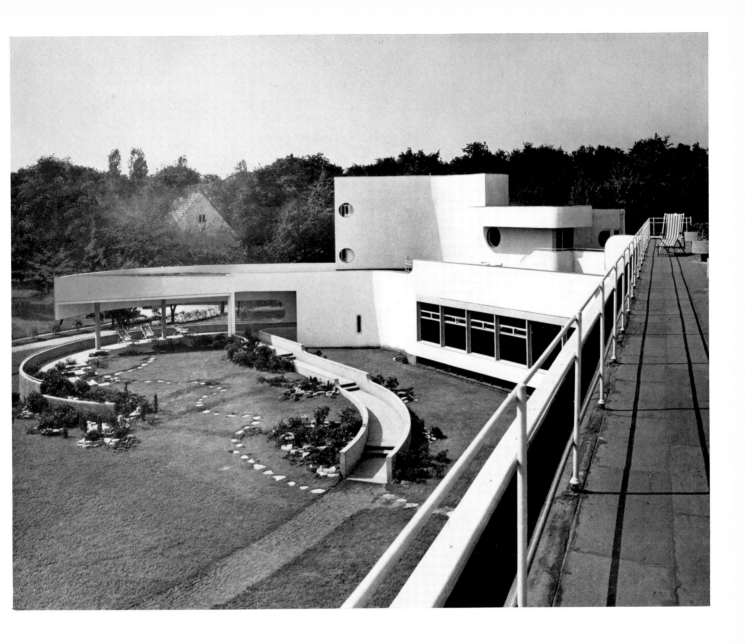

47
Hans Scharoun
Hostel for bachelors, Breslau, 1929

48
Le Corbusier and Pierre Jeanneret
Swiss student hostel in the Cité Universitaire,
Paris, 1930

IV
A. M. Cassandre
Poster for an ocean liner, Paris, 1931

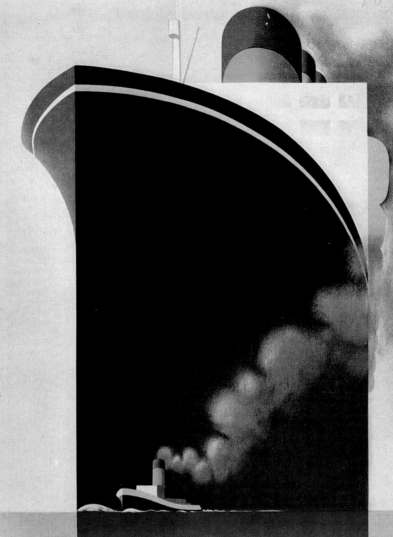

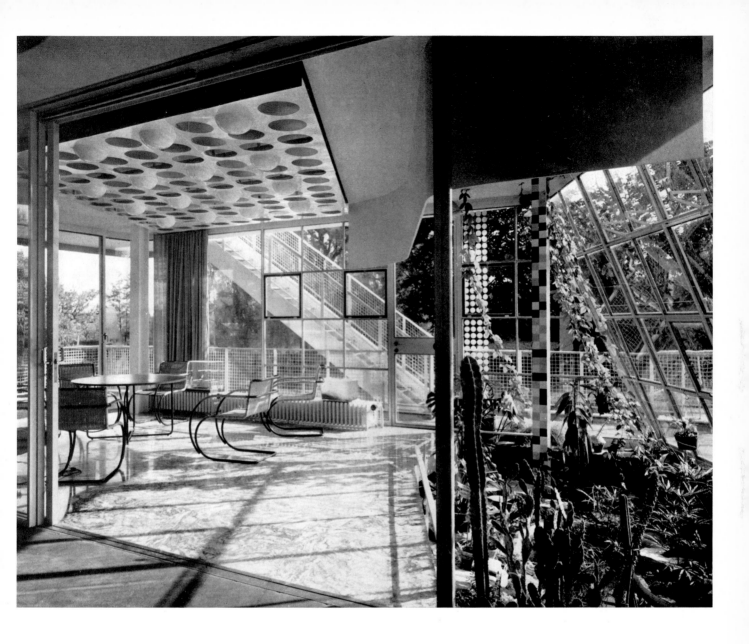

49
Hans Scharoun
Schminke House, Löbau, Silesia, 1932

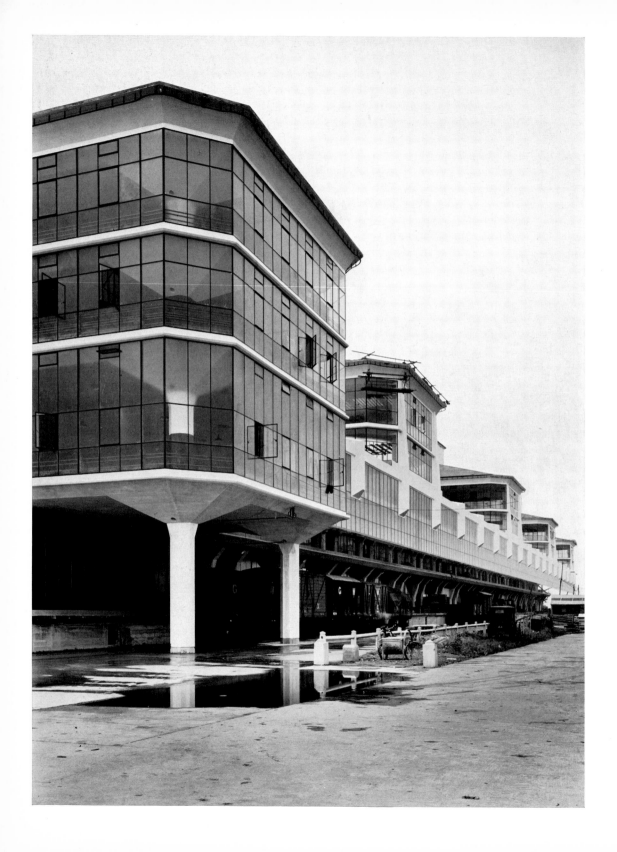

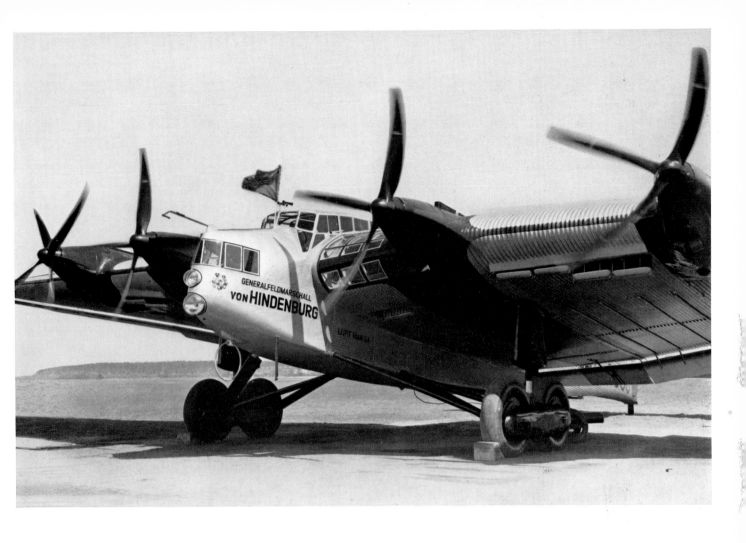

50
E. Owen Williams
Boots' pharmaceutical factory, Beeston,
Nottingham, England, 1930

51
Junkers Flugzeugwerke, Germany
G 38 airliner 'Generalfeldmarschall
von Hindenburg', 1930

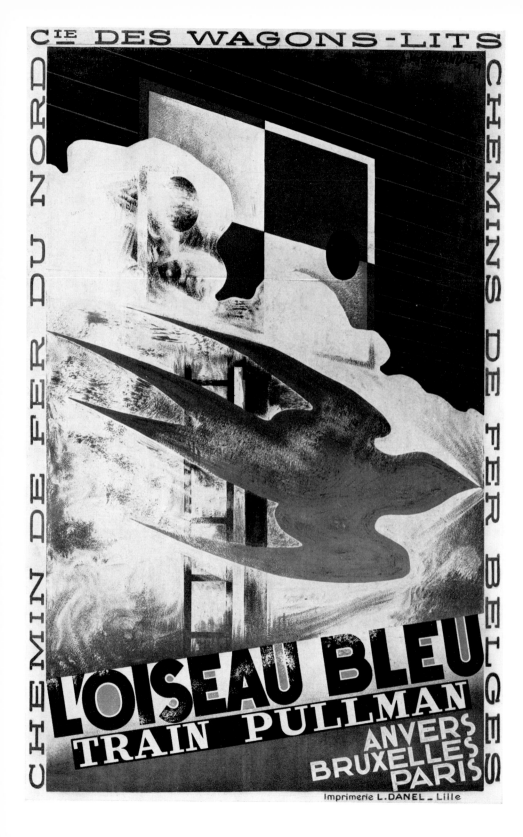

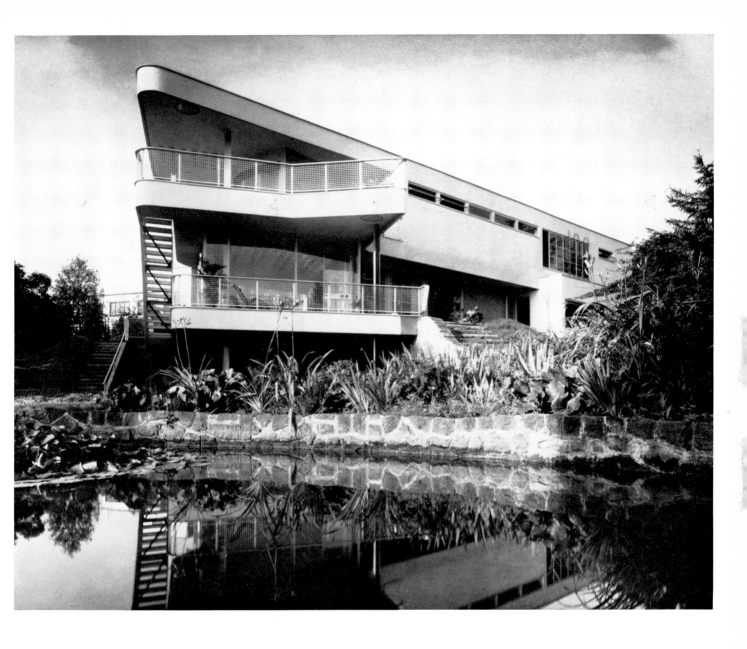

52
A. M. Cassandre
Poster for a luxury train, Paris, 1929

53
Hans Scharoun
Schminke House, Löbau, Silesia, 1932

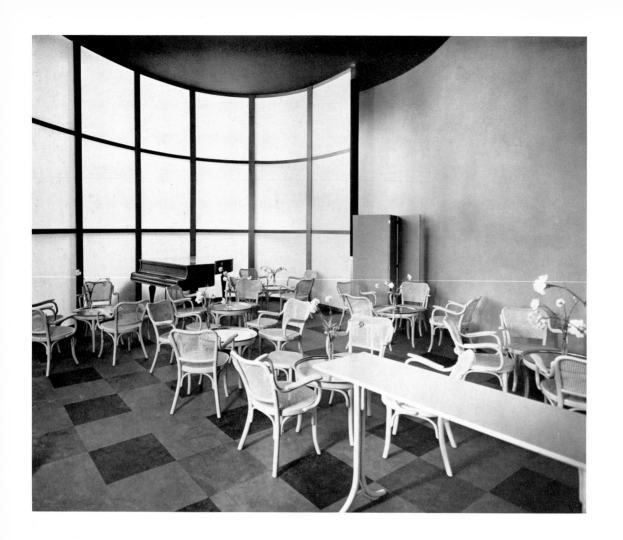

54
Josef Frank
Tearoom, Vienna 1930

55
Erik Gunnar Asplund
Stockholm Exhibition, 1930

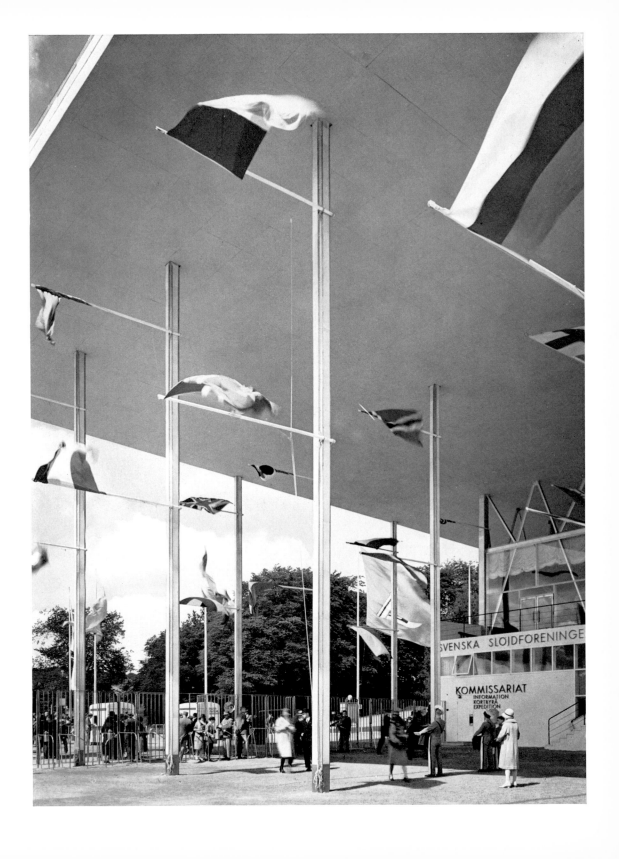

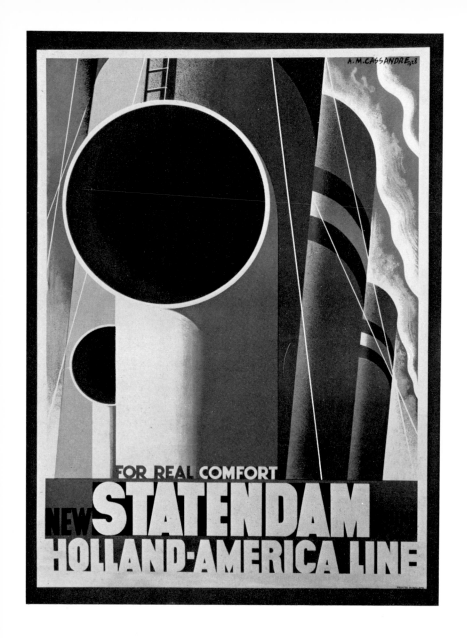

56
A. M. Cassandre
Poster for an ocean liner, Paris, 1928

57
Erik Gunnar Asplund
Paradise Restaurant, Stockholm Exhibition, 1930

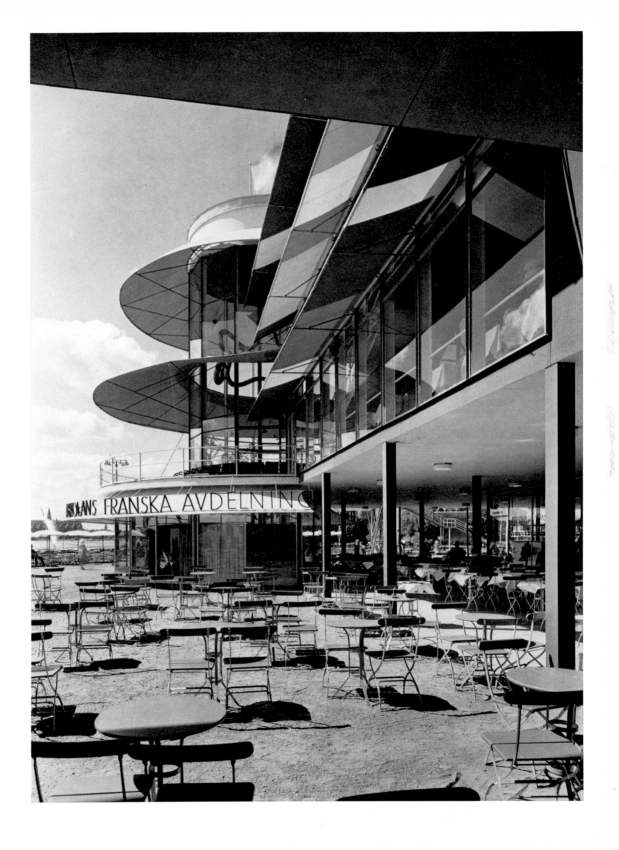

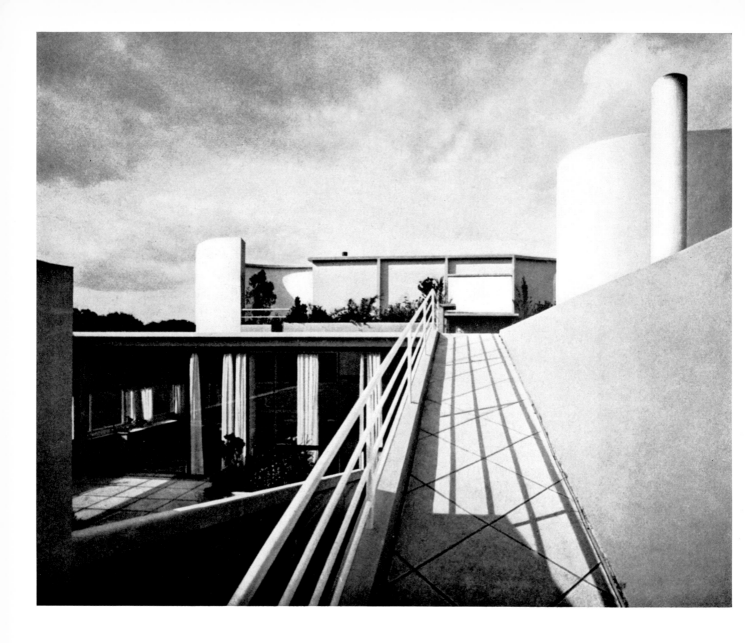

58
Le Corbusier and Pierre Jeanneret
Villa Savoye, Poissy, near Paris, 1928

59
A. M. Cassandre
Poster for a Channel ferry, Paris, 1931

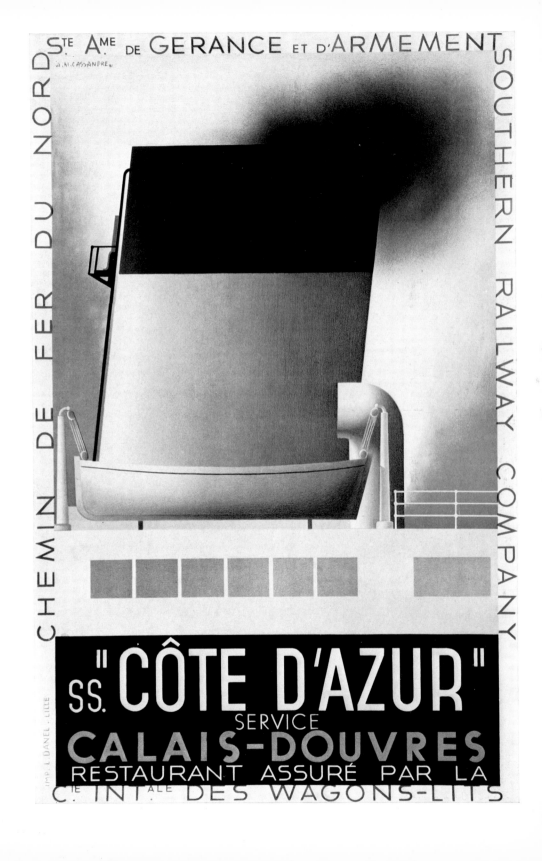

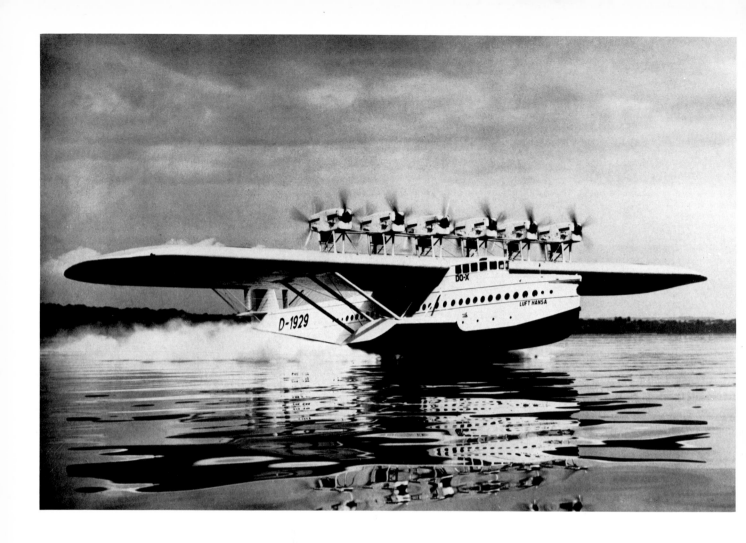

60
Dornier-Flugzeugwerke, Germany
Do-X flying boat, 1929

V
Alfred Mahlau
Travel poster, Lübeck, 1929

LA FINLANDE
PAYS DES 30 000 LACS

POUR ALLER EN FINLANDE
UTILISEZ LA VOIE LA PLUS
RAPIDE ET LA PLUS ÉCONOMIQUE
VIA HAMBURG-LÜBECK
PAR LES VAPEURS DE LA
FINSKA-ÅNGFARTYGS-AKTIEBOLAGET
[Cie FINLANDAISE DE NAVIGATION À VAPEUR]
RENSEIGNEMENTS ET BILLETS ICI

ALFRED MAHLAU 1929

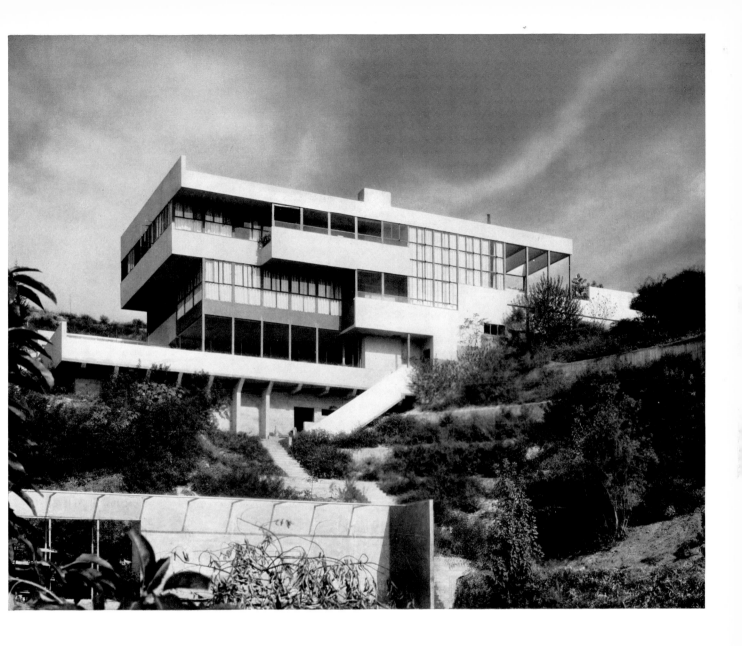

61
Richard Neutra
Health House, Los Angeles, 1927

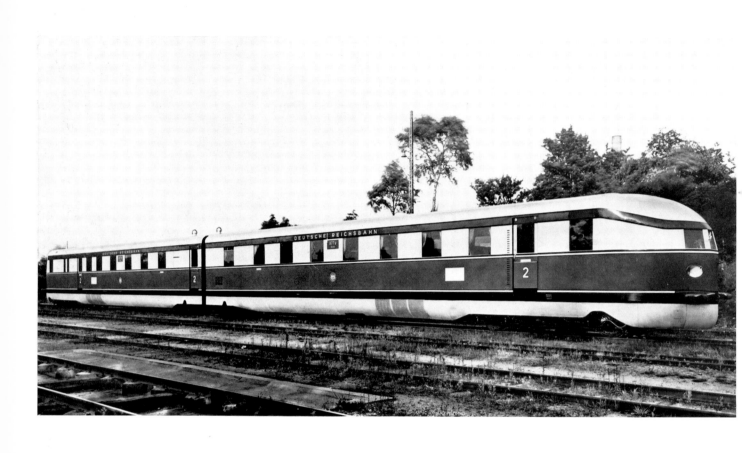

62
German state railways
The diesel train 'Fliegender Hamburger', 1933

63
Pier Luigi Nervi
Stadium, Florence, 1930

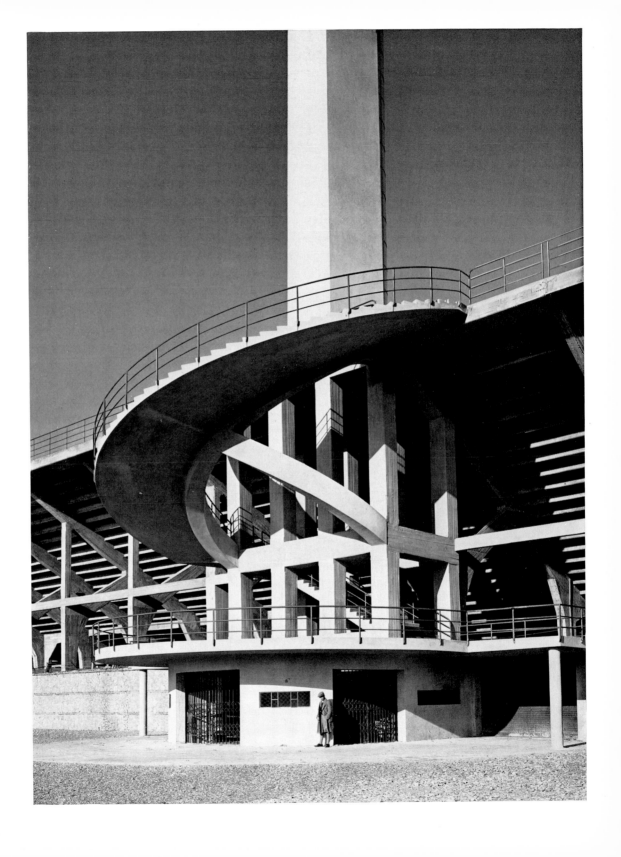

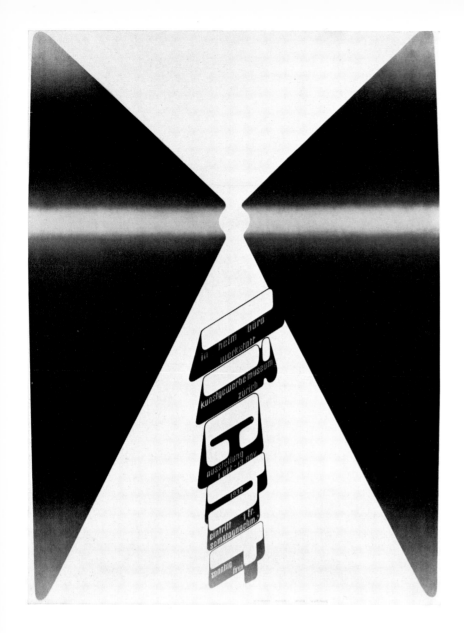

64
Alfred Willimann
Poster for a lighting exhibition, Zürich, 1932

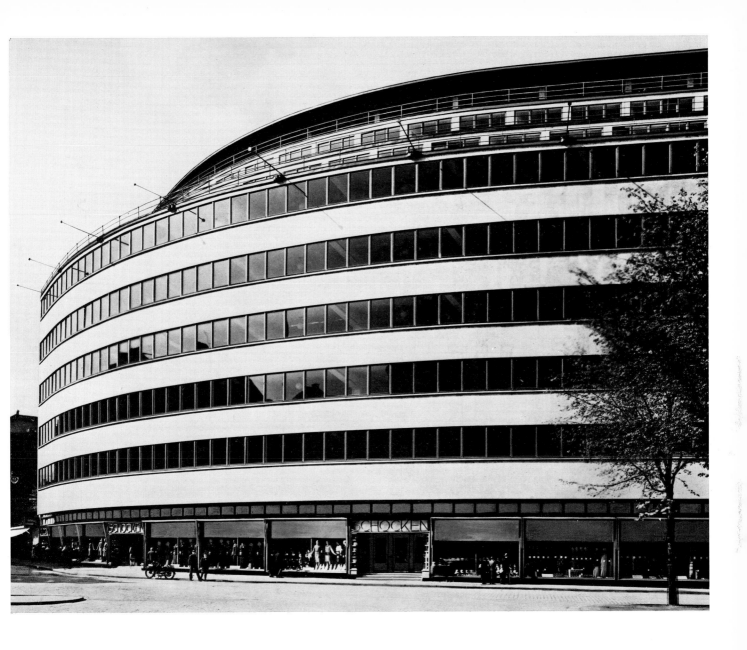

65
Erich Mendelsohn
Schocken department store, Chemnitz, 1927

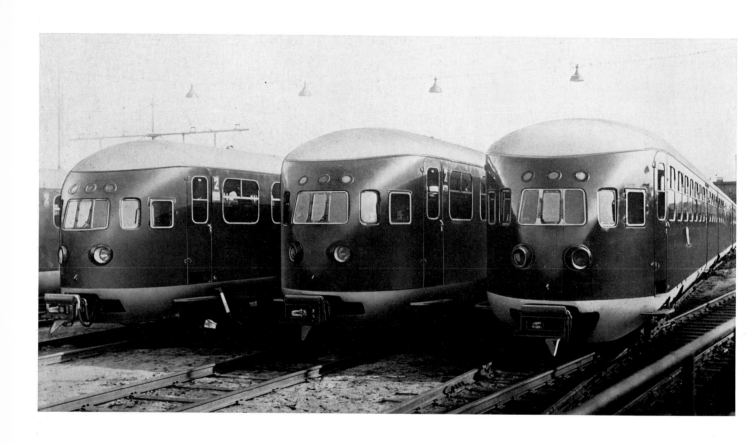

66
Dutch state railways
Diesel units, 1935

67
A. M. Cassandre
Poster for a luxury train, Paris, 1927

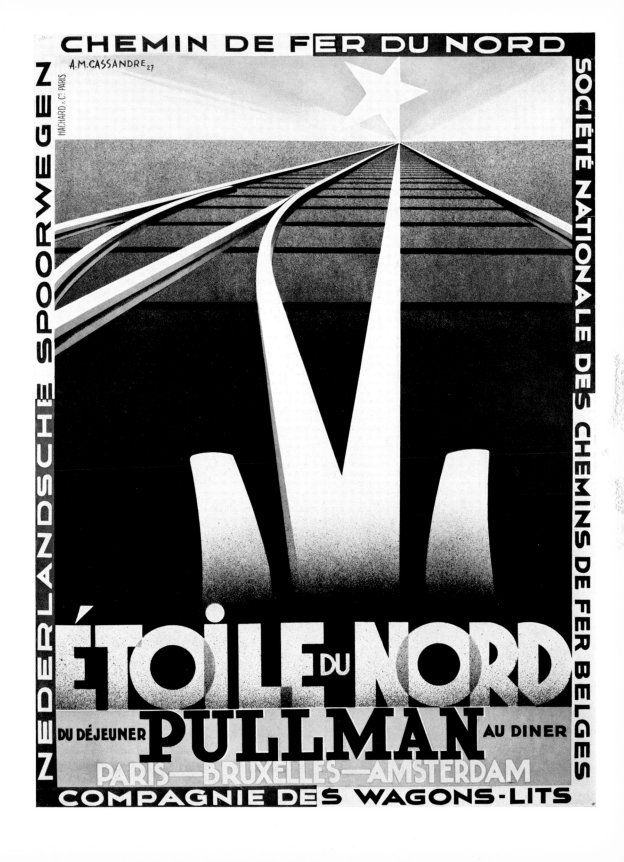

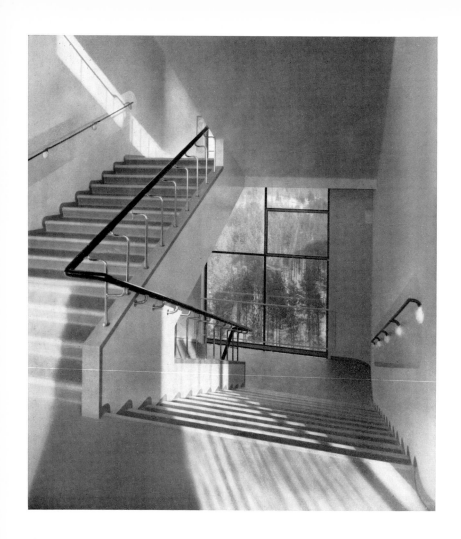

68–69
Alvar Aalto
Sanatorium in Paimio, Finland, 1929

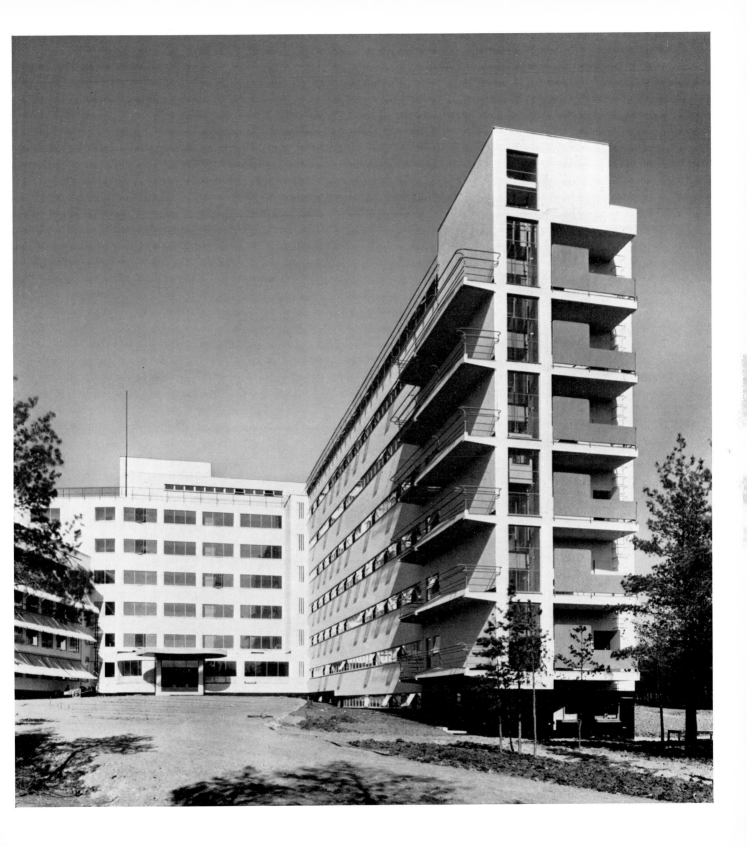

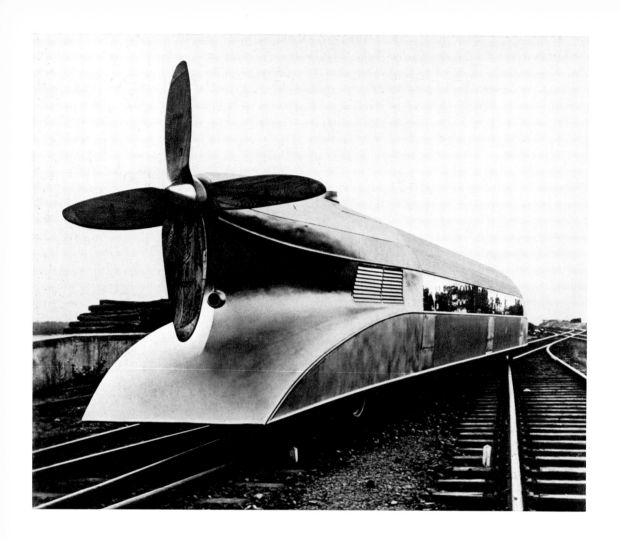

70
Hans Kruckenberg
Schienenzepp experimental train, 1930

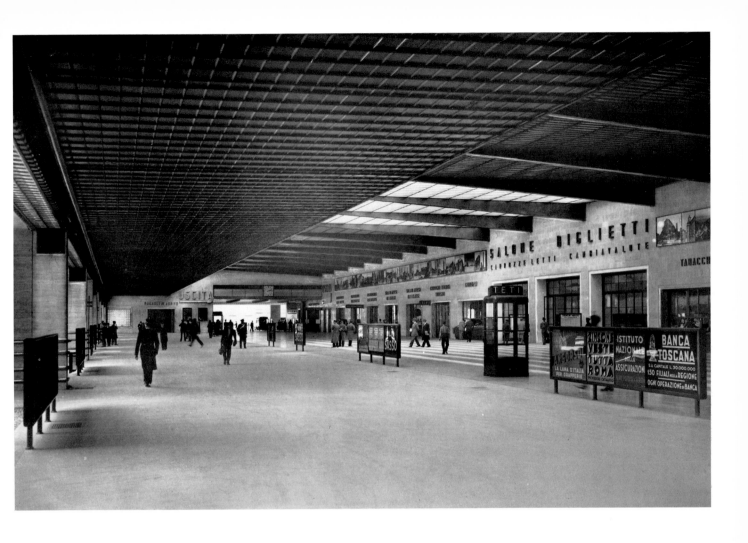

71
Giovanni Michelucci and collaborators
Santa Maria Novella railway station, Florence, 1933

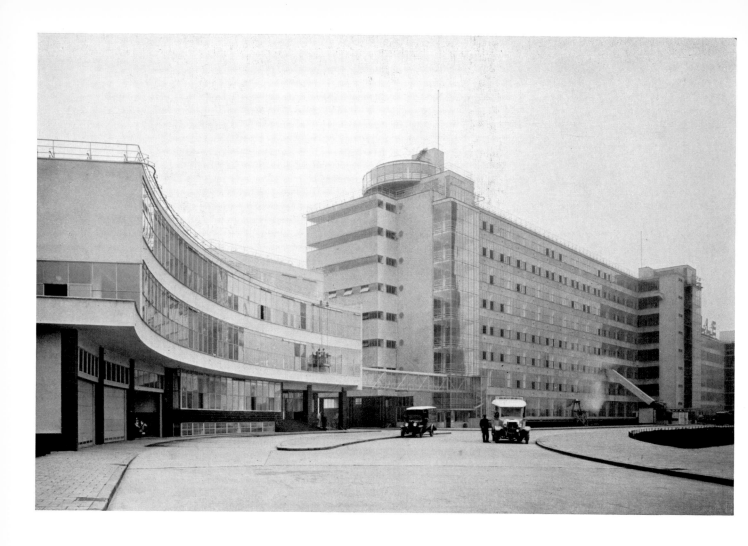

72
Johannes Andreas Brinkman and
L. C. van der Vlugt, with Mart Stam
Van Nelle tobacco factory, Rotterdam, 1928

VI
A. M. Cassandre
Poster for French state railways, Paris, 1929

CHEMIN DE FER DU NORD

VITESSE-LUXE-CONFORT

A.M. CASSANDRE 29

IMP. L. DANEL - LILLE

PART 2

THE PHOTOGRAPHERS

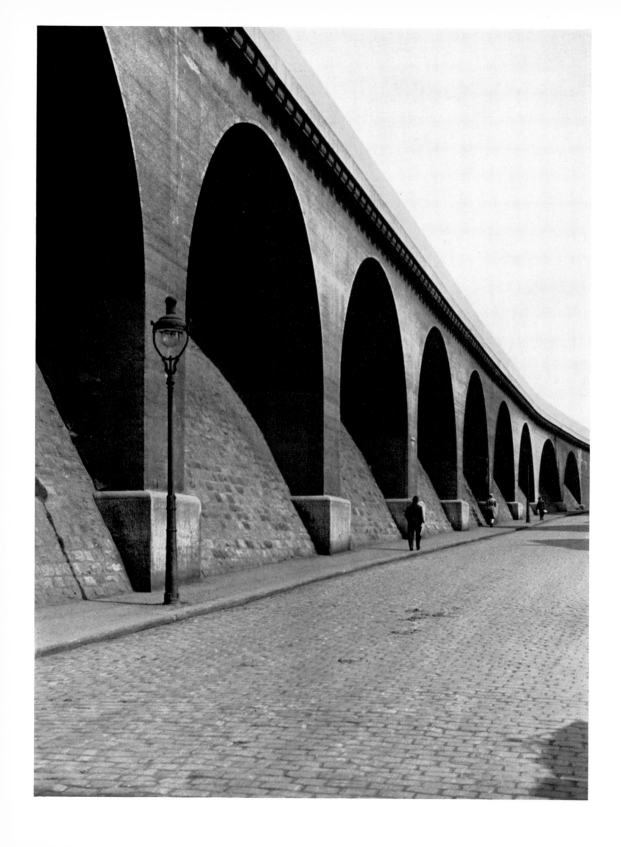

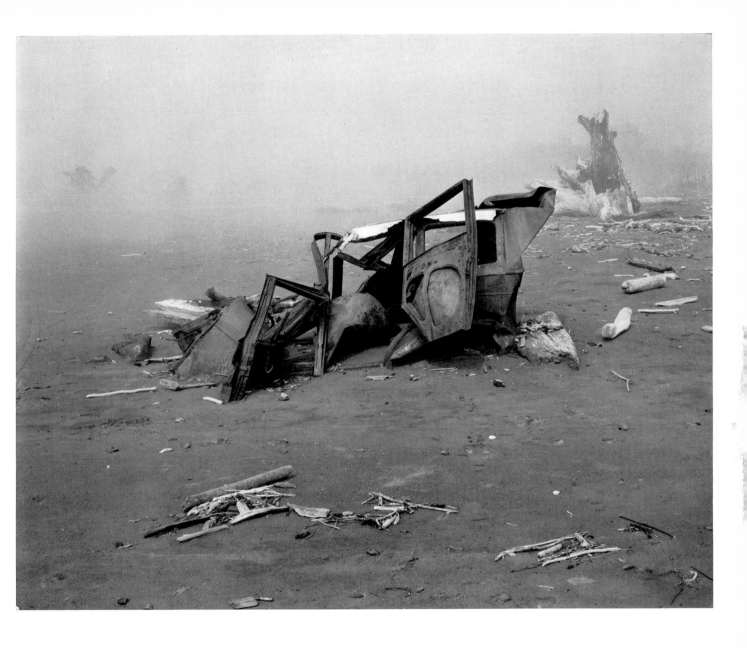

73
Albert Renger-Patzsch
Railway embankment, Essen, 1930

74
Edward Weston
Wrecked car, North
America, 1931

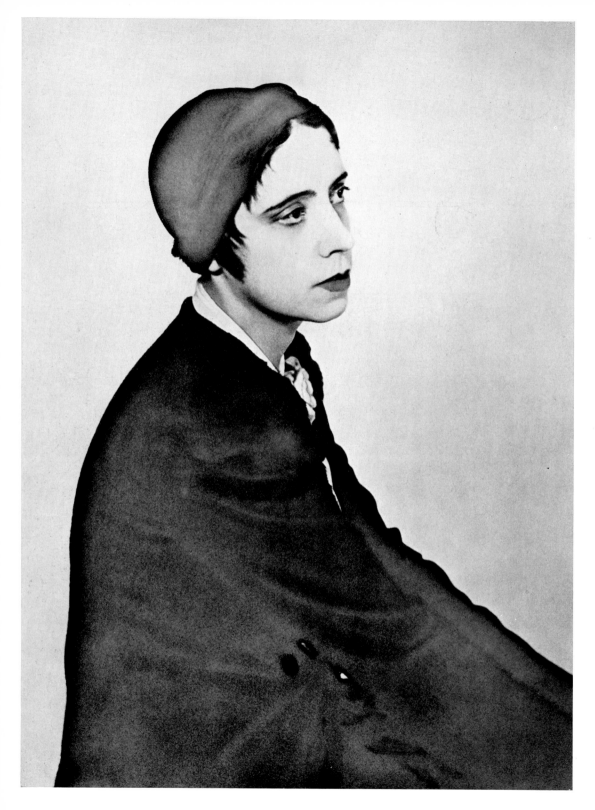

75
Man Ray
Elsa Schiaparelli,
Paris, 1930

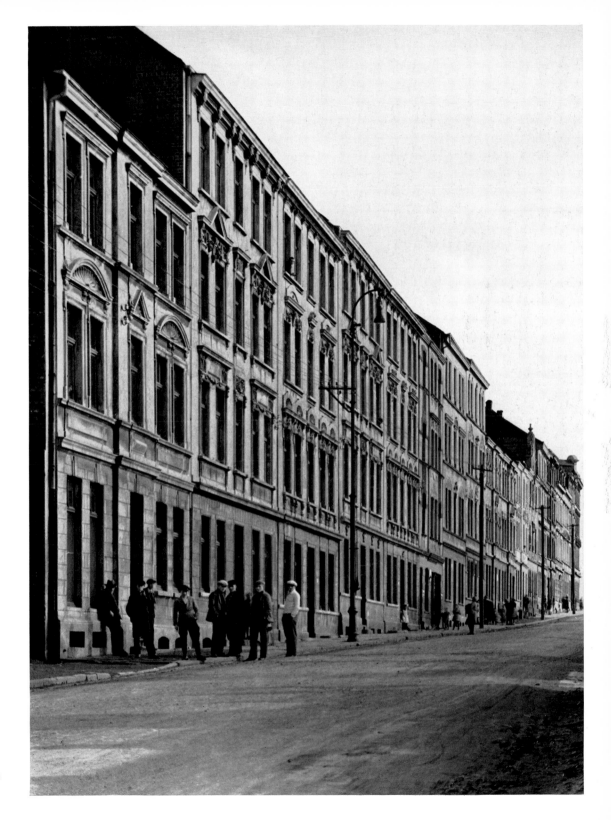

76
Albert Renger-Patzsch
Street, Essen, 1932

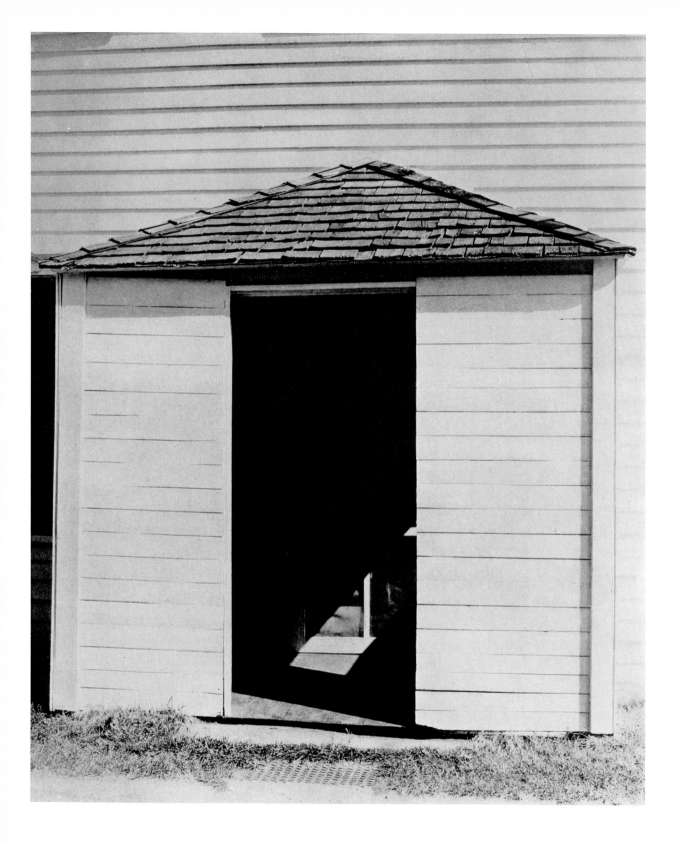

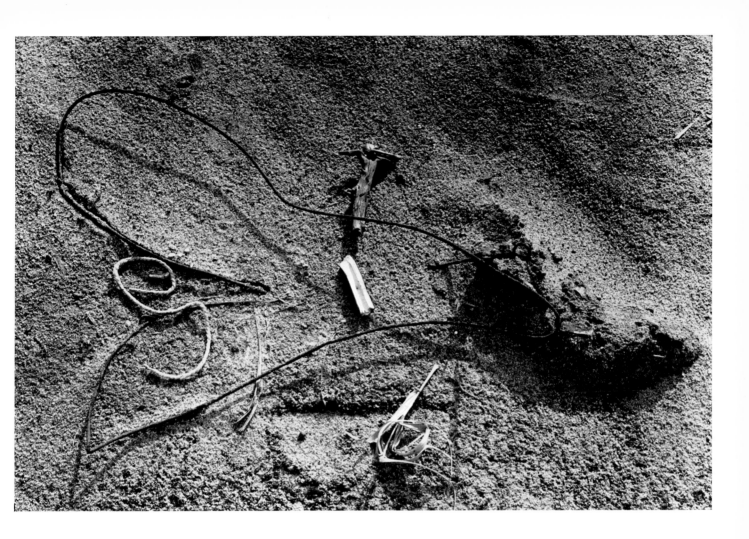

77
Alfred Stieglitz
Lake George, 1934

78
Walter Peterhans
Photographic study, Dessau, c. 1930

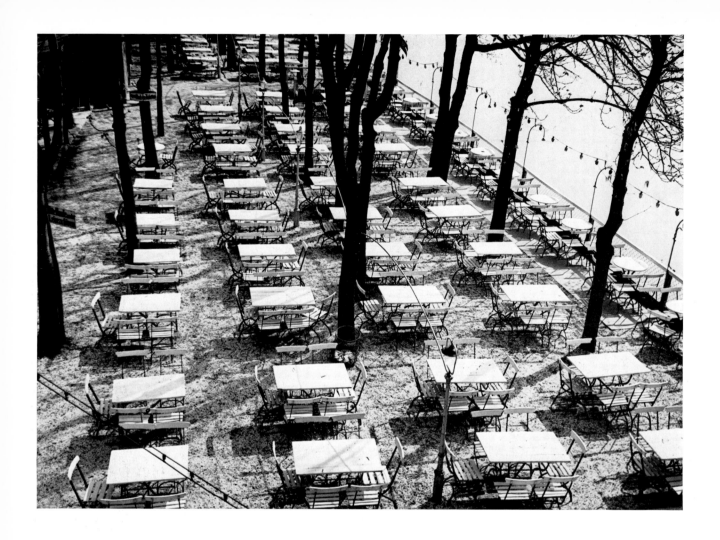

79
Hildegard Heise
Coffee garden on the river Saale, Halle, 1929

80
Brassaï
Man with white sunshade, Menton, 1935

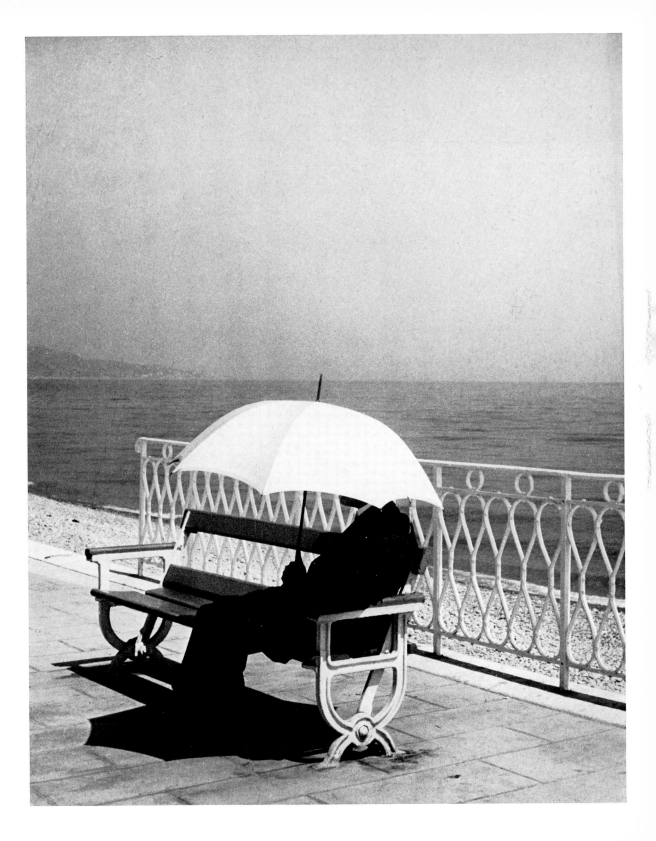

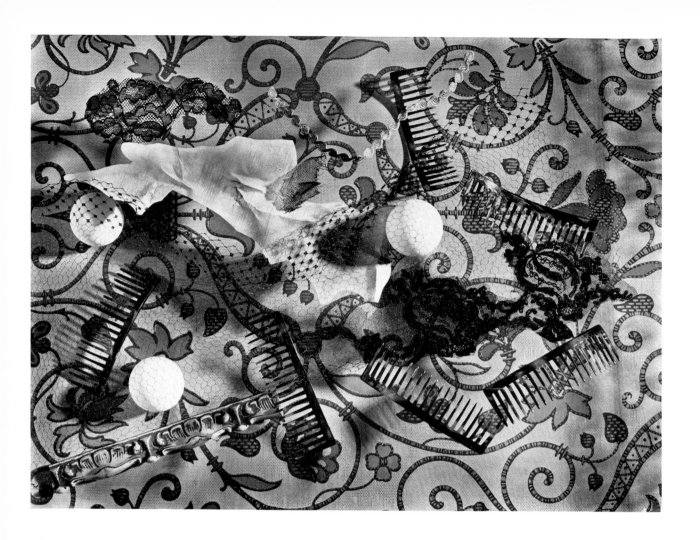

81
Walter Peterhans
Photographic study, Dessau, c. 1930

82
Cecil Beaton
Photograph,
London, c. 1930

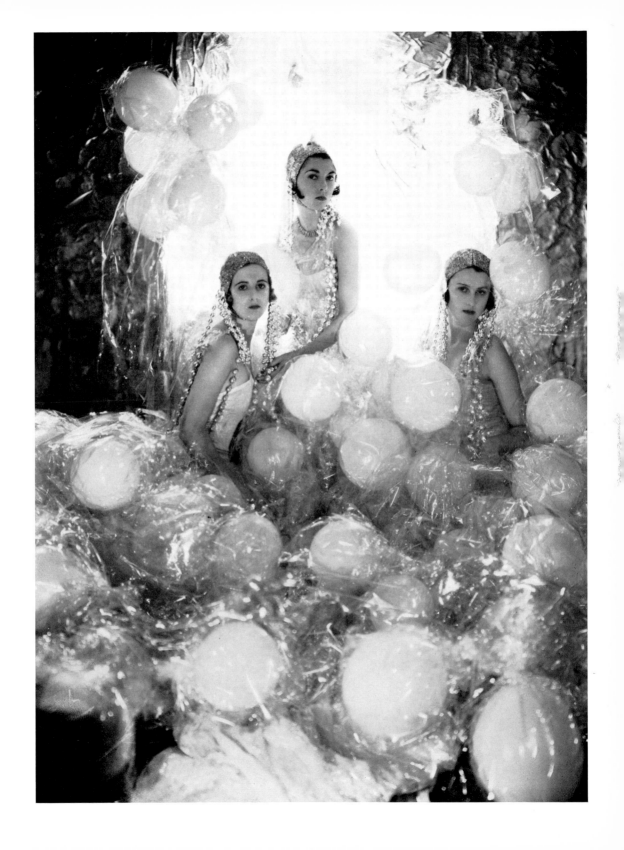

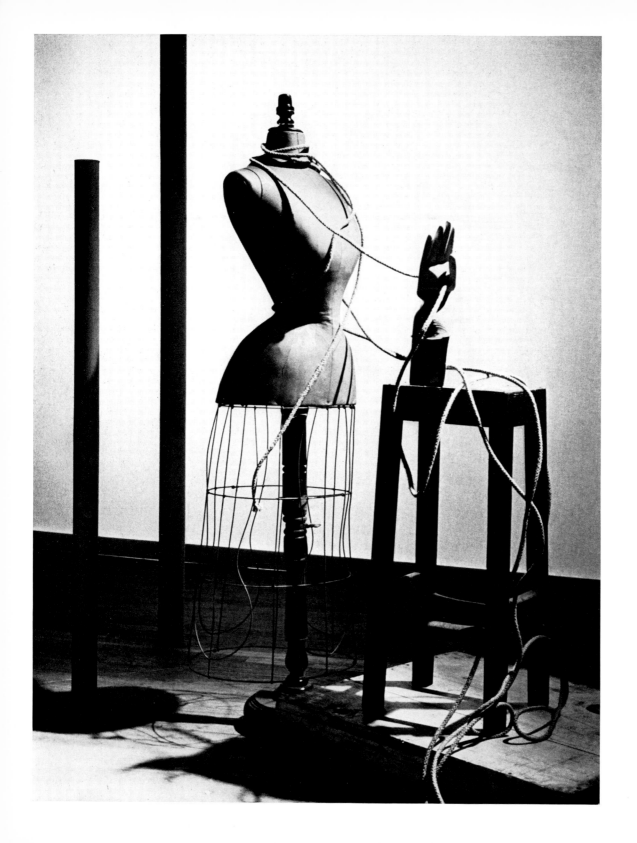

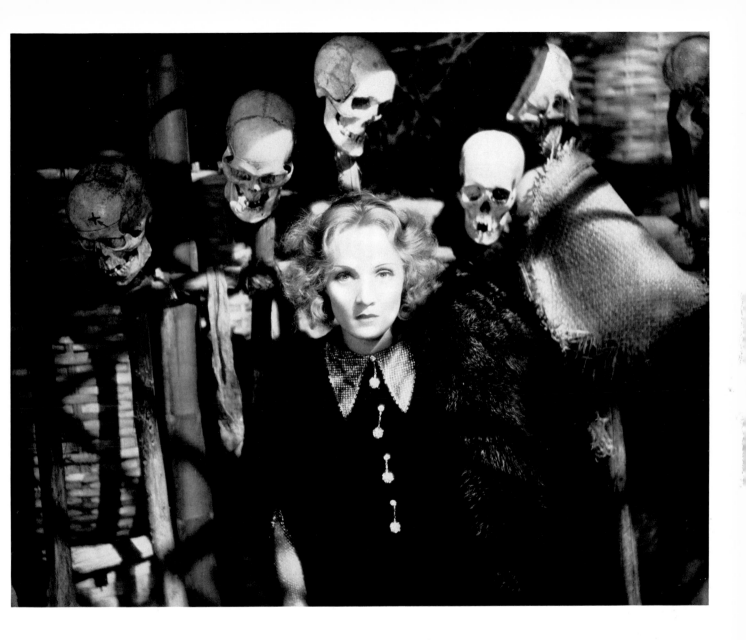

83
Herbert List
The Slave-girl,
London, 1934

84
Josef von Sternberg
Still from the film 'Shanghai-Express',
with Marlene Dietrich, Hollywood, 1932

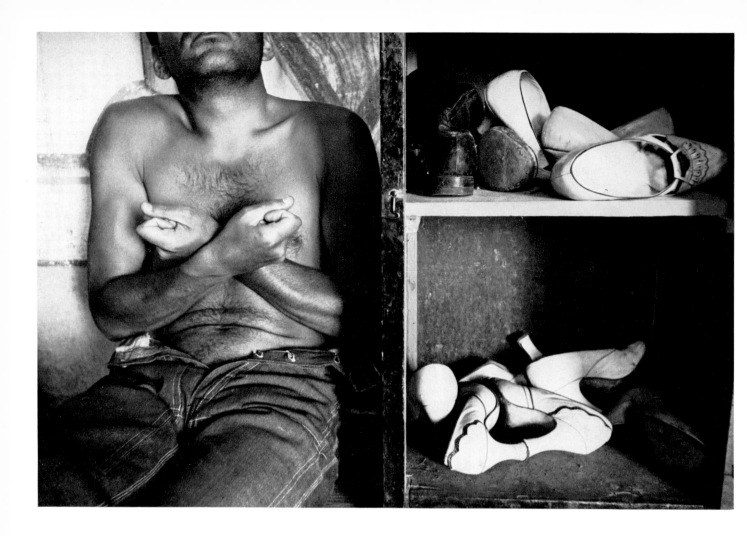

85
Henri Cartier-Bresson
Photograph, Mexico, 1934

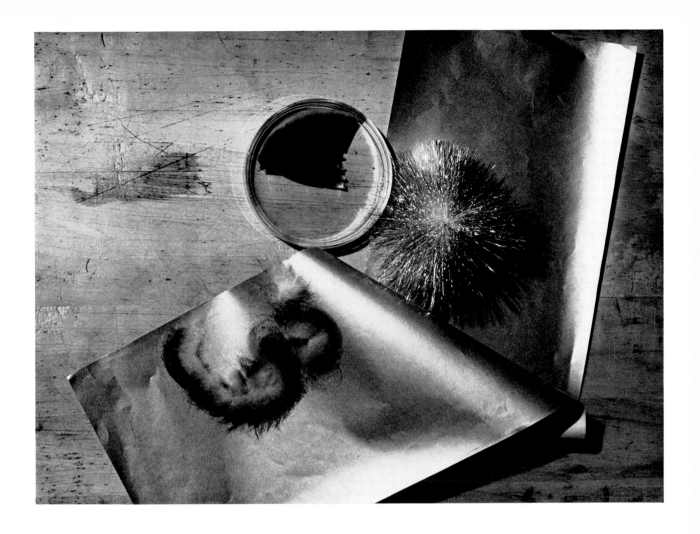

86
Walter Peterhans
Photographic study, Dessau, c. 1930

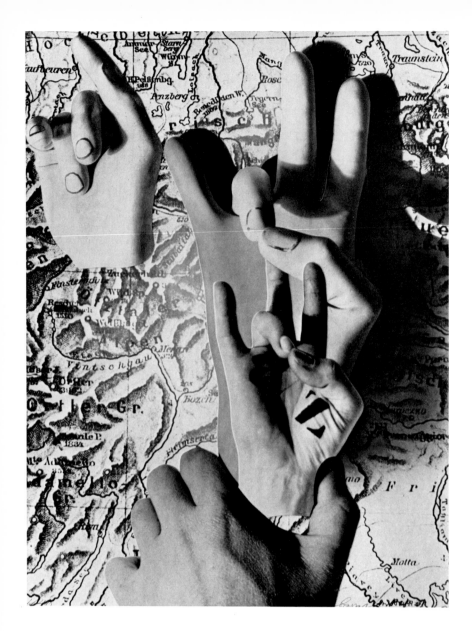

87
Herbert Bayer
Creative Hands, 1932

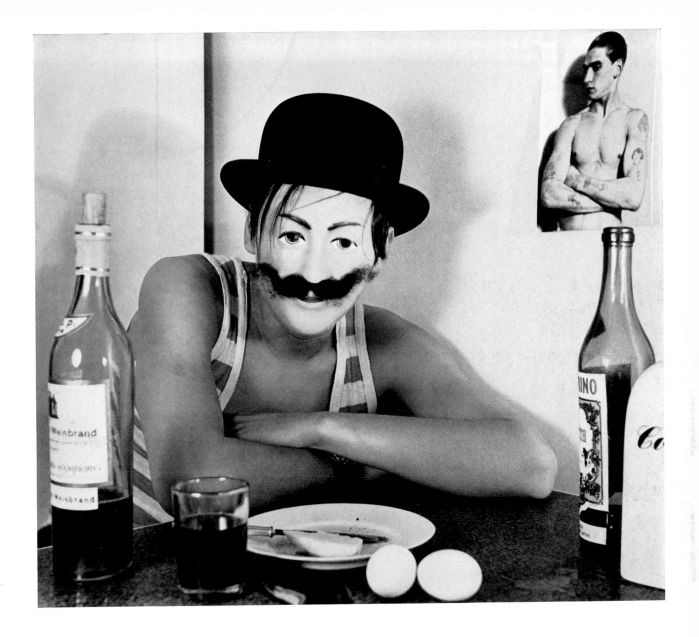

88
Herbert List
The Moustache, Hamburg, 1931

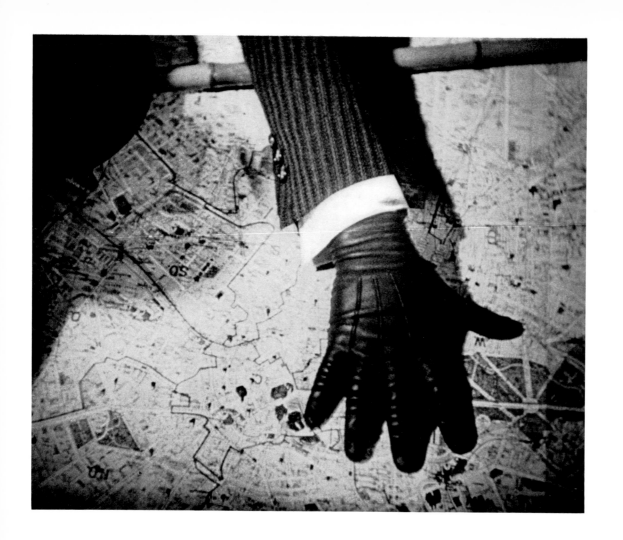

89
Fritz Lang
Scene from the Film 'M', Germany, 1930

90
Herbert Bayer
Self-portrait, Berlin, 1932

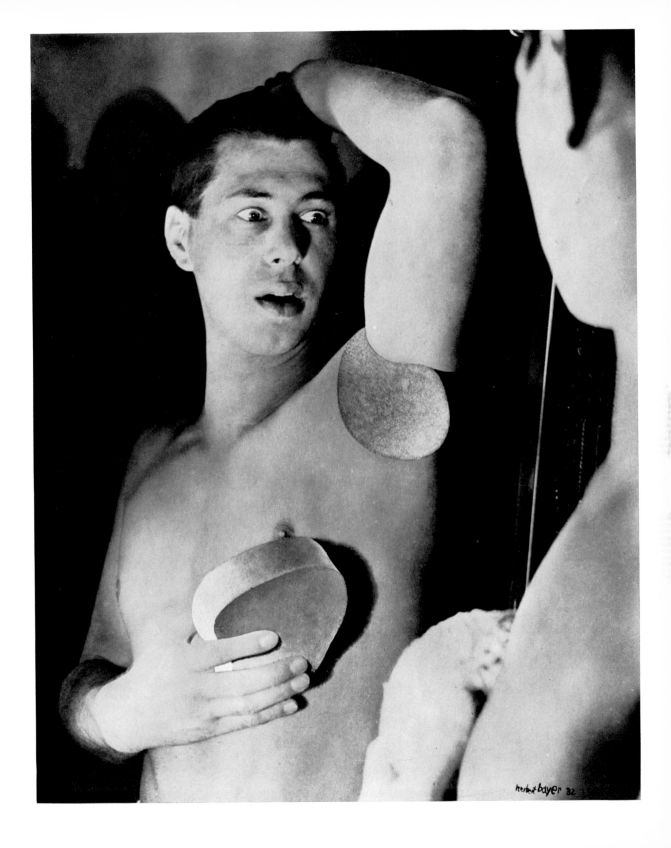

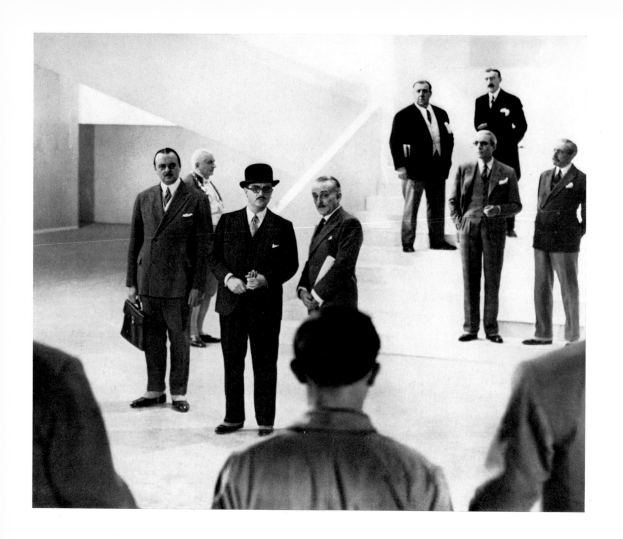

91
René Clair
Scene from the film 'A nous la liberté', France, 1930

92 (overleaf)
Niklaus Stoecklin
Poster for the fashion house PKZ, Zürich, 1934

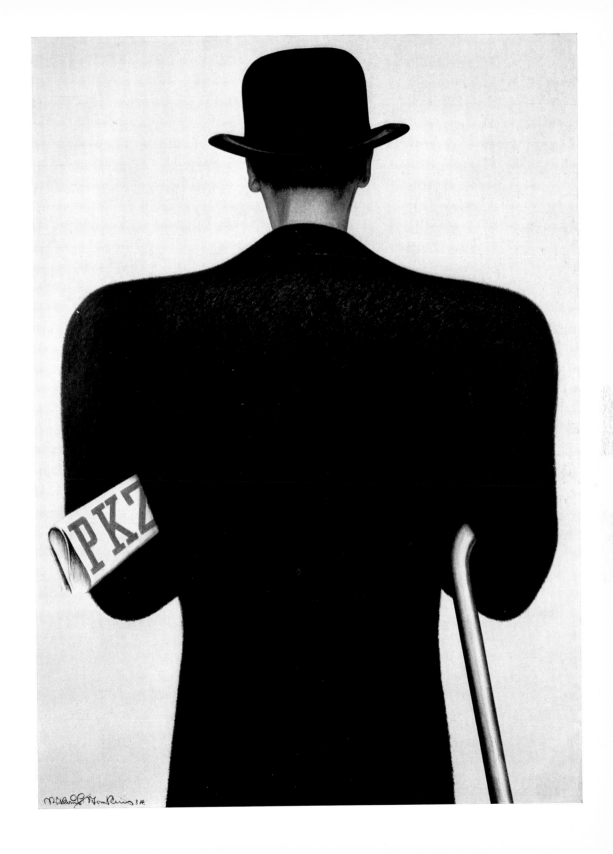

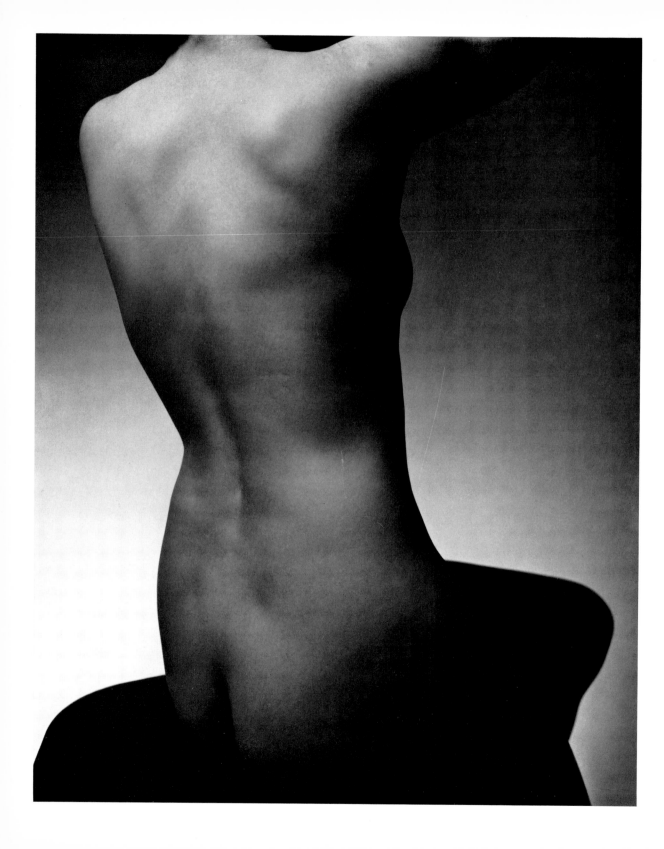

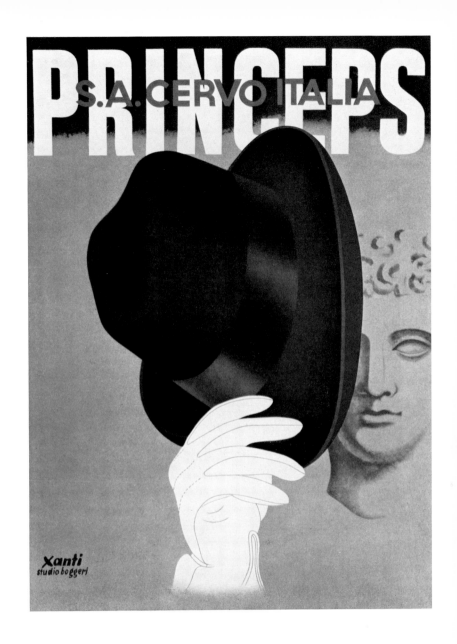

93 (preceding page)
Edward Steichen
Photograph for 'Vogue', New York, 1934

94
Xanti Schawinski
Advertisement for a fashion house, Milan, 1934

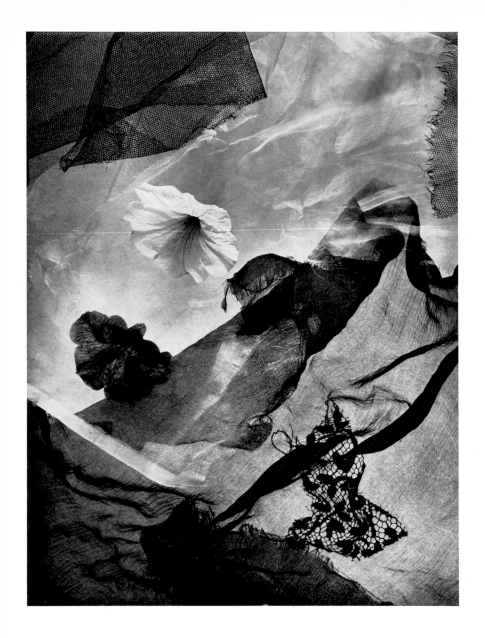

95
Walter Peterhans
Photographic study, Dessau, c. 1930

VII
Max Ernst
Interior, Corso-Bar, Zürich, 1934

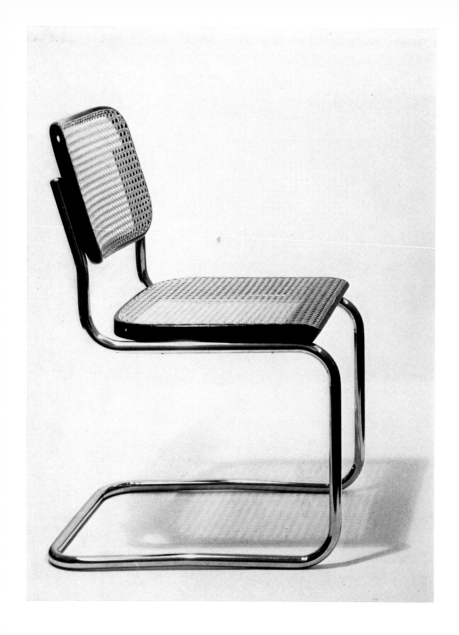

96
Marcel Breuer
S 32 chair, Germany, 1927

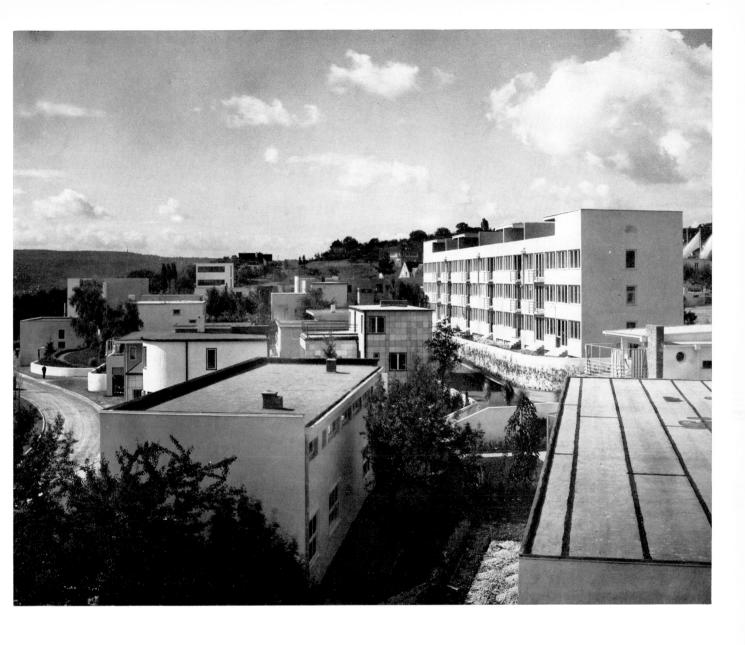

97
Ludwig Mies van der Rohe and others
Weissenhof housing estate, Stuttgart, 1927

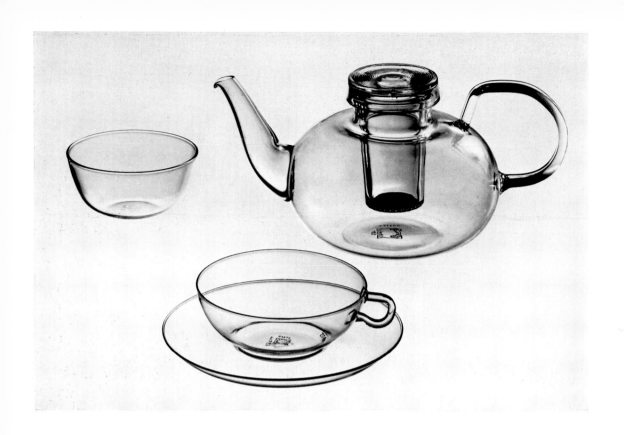

98
Wilhelm Wagenfeld
Fireproof glassware, 1932

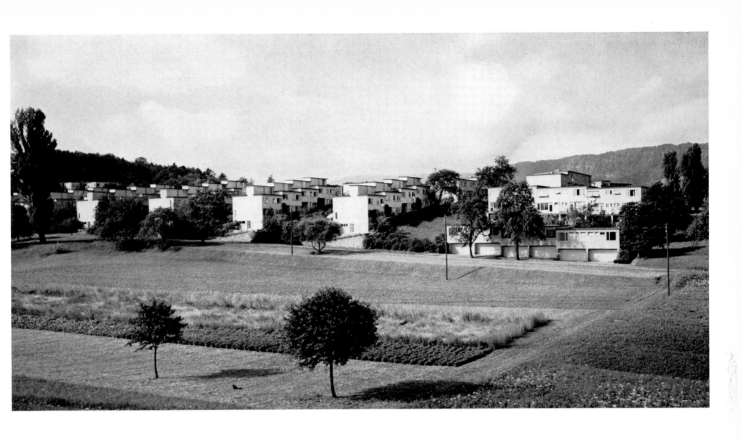

99
Werner M. Moser, Carl Hubacher, Emil Roth,
Rudolf Steiger, Hans Schmidt, Paul Arteria
Neubühl housing estate, near Zürich, 1930

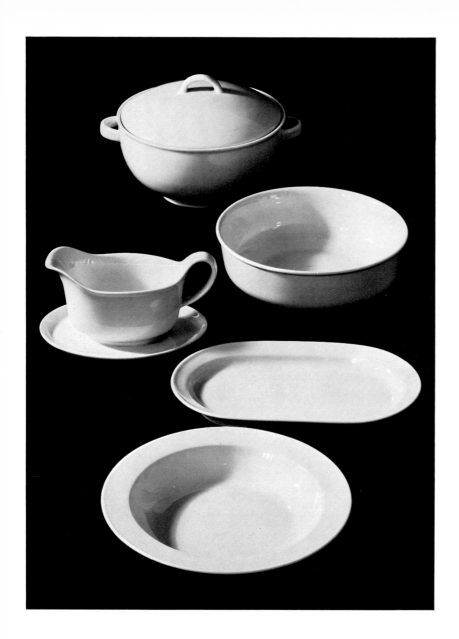

100
Hermann Gretsch
Arzberg 1382 chinaware, 1931

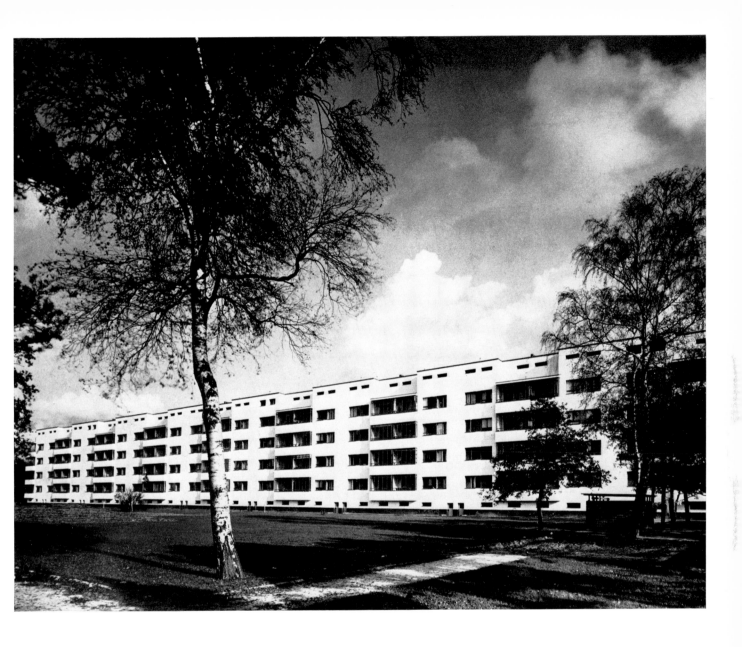

101
Walter Gropius
Flats in Siemensstadt housing estate, Berlin, 1929

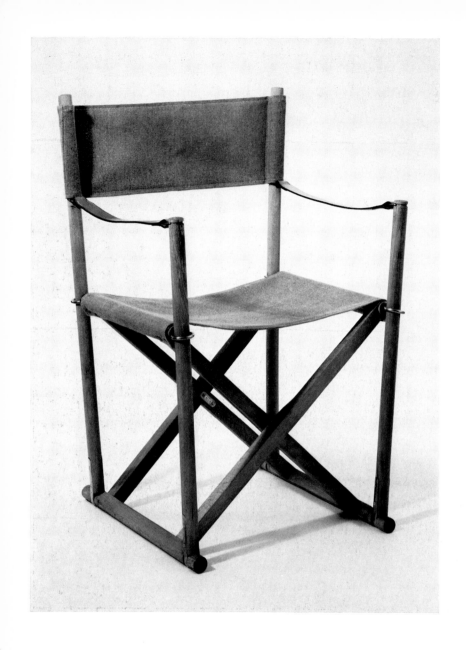

102
Mogens Kock
Folding chair, Denmark, 1933

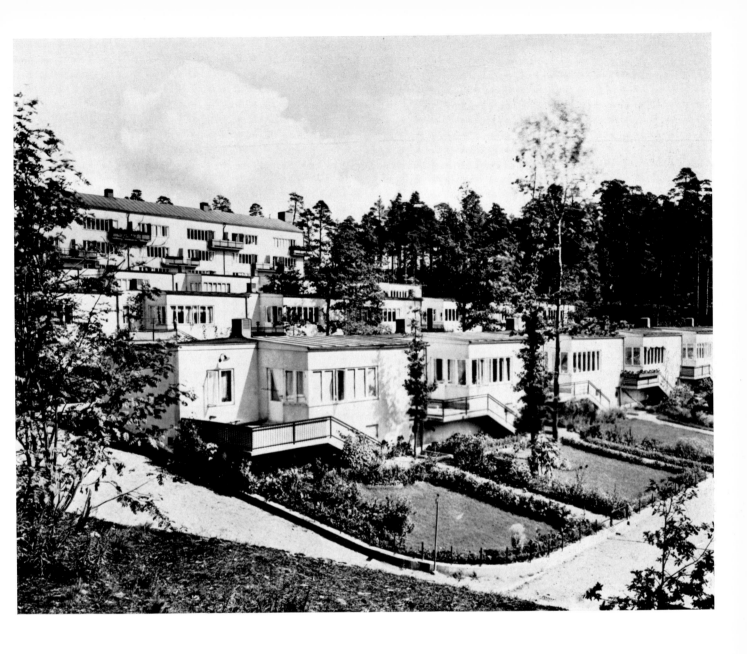

103
Olof Thunström
Hästholmen housing estate, near Stockholm, 1932

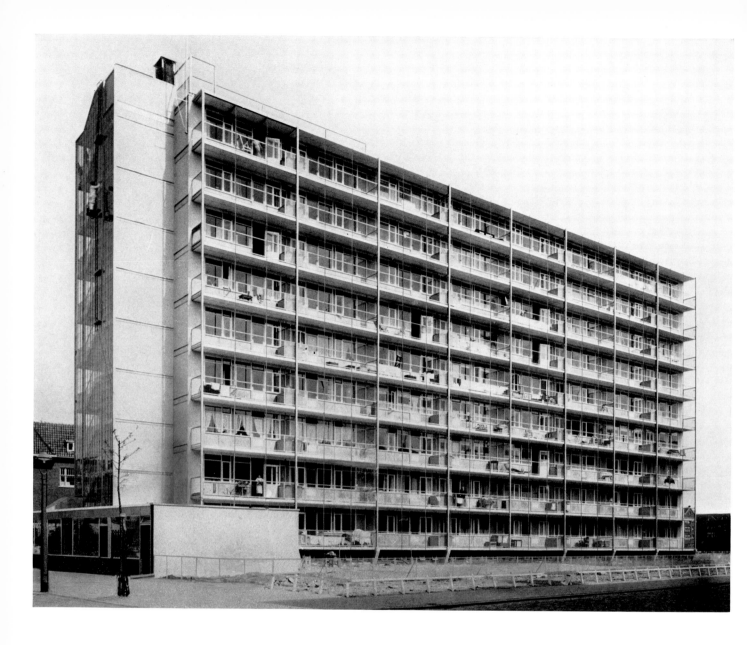

104
Johannes Andreas Brinkmann
and J. C. van der Vlugt
Bergpolder apartment block, Rotterdam, 1933

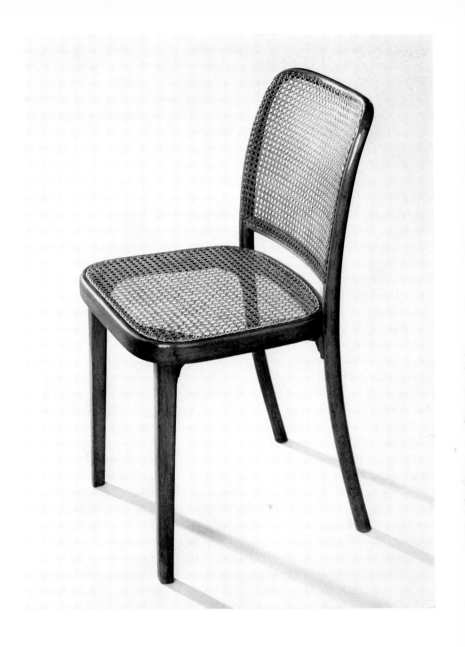

105
Gebrüder Thonet AG
Chair, Austria, c. 1930

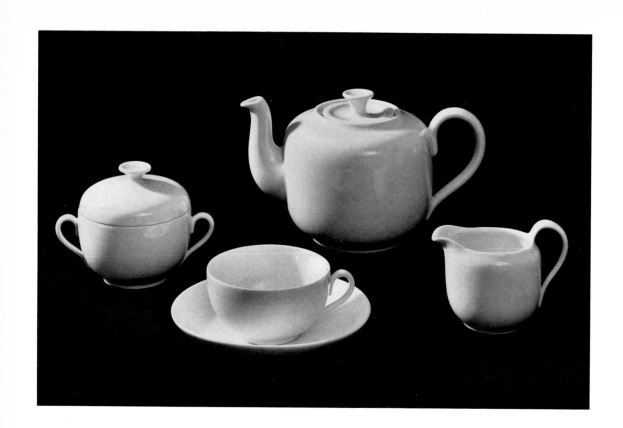

106
Ebbe Sadolin
Chinaware, 1932

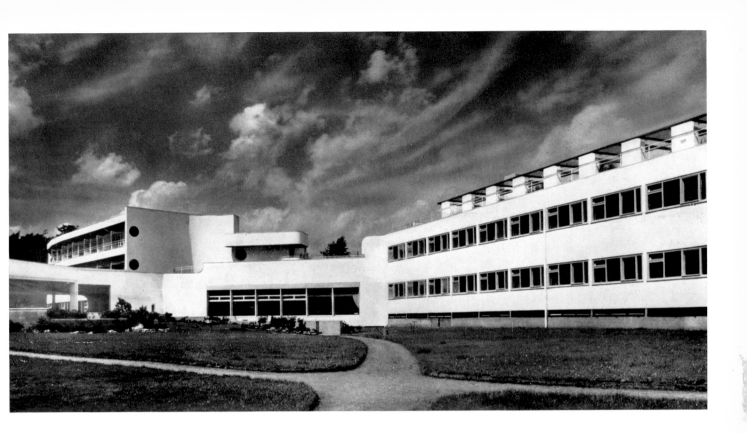

107
Hans Scharoun
Hostel for bachelors, Breslau 1929

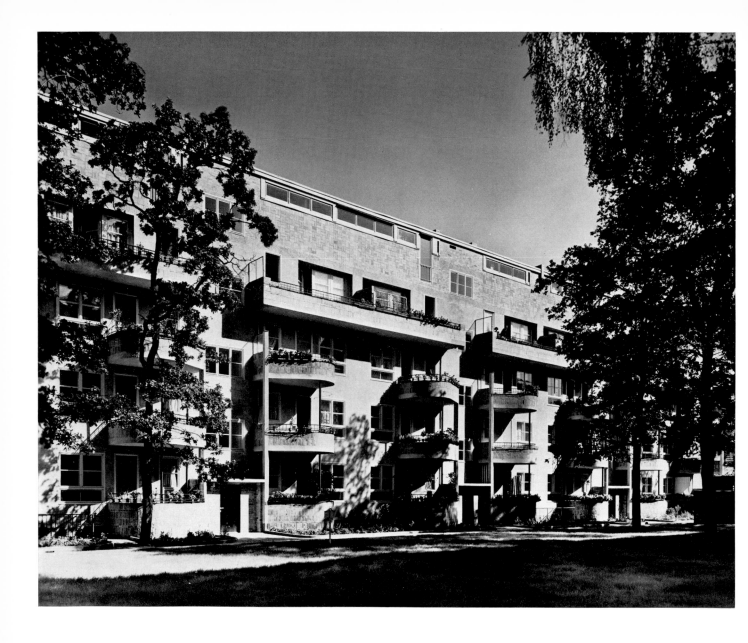

108
Hugo Häring
Flats in Siemensstadt housing estate, Berlin, 1930

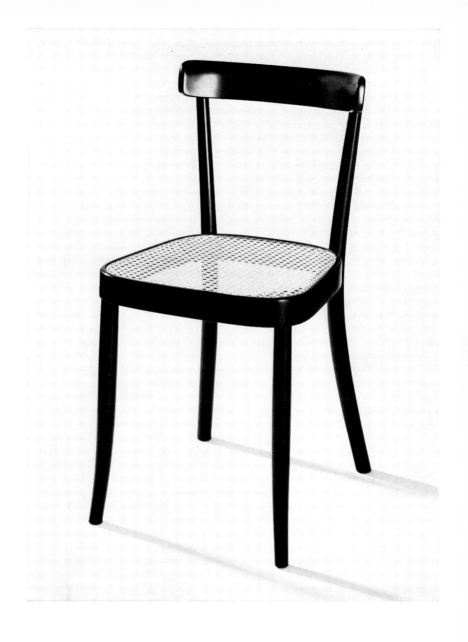

109
Werner M. Moser
Chair, 1929

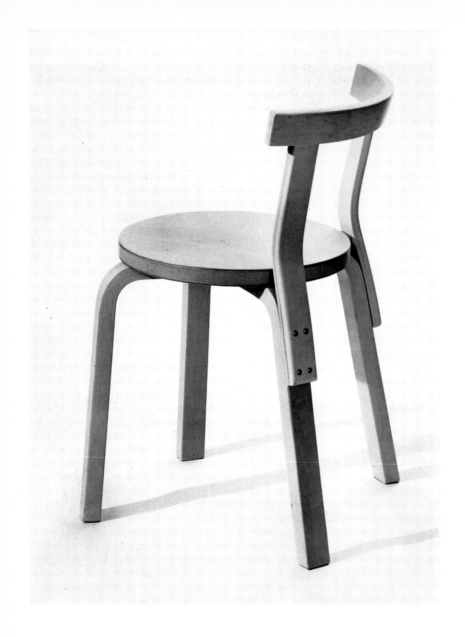

110
Alvar Aalto
Stacking chair, c. 1930

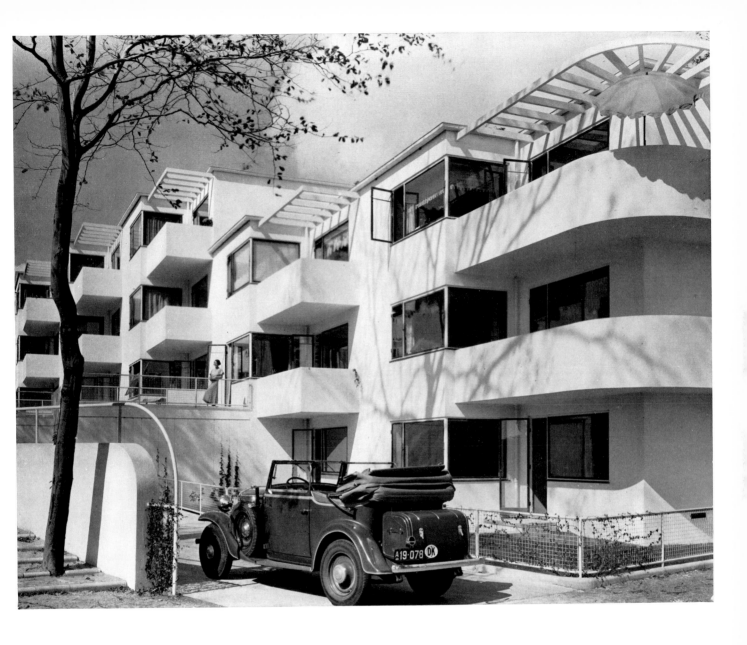

111
Arne Jacobsen
Bellavista flats, Klampenborg, near Copenhagen,
1932

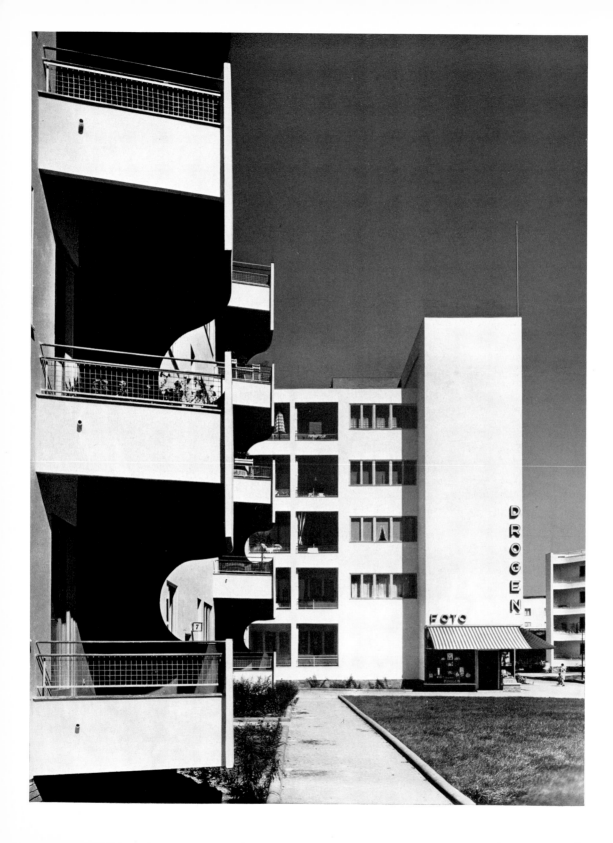

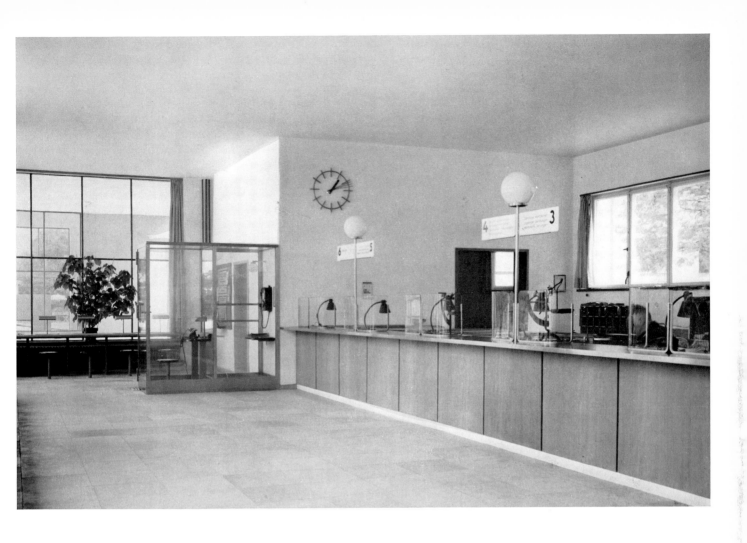

112
Hans Scharoun
Blocks of flats in Siemensstadt housing estate, Berlin,
1929

113
Robert Vorhoelzer and Walther Schmidt
Post office, Munich, c. 1930

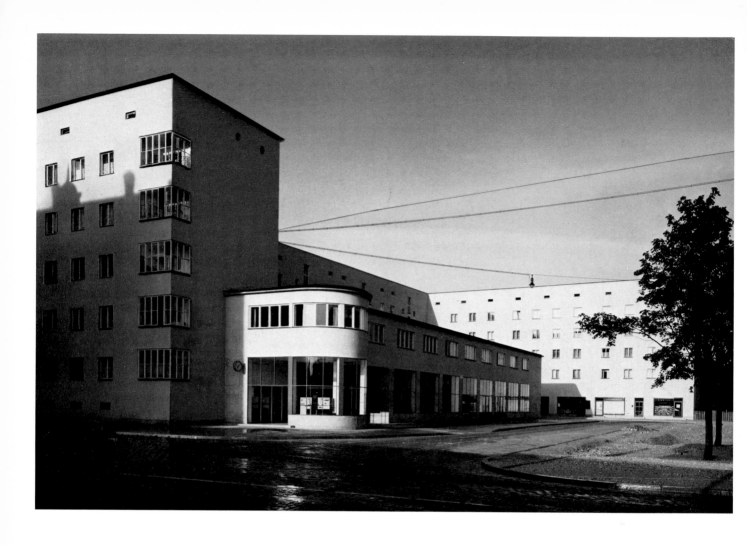

114
Robert Vorhoelzer and Walther Schmidt
Block of flats with post office, Munich, c. 1930

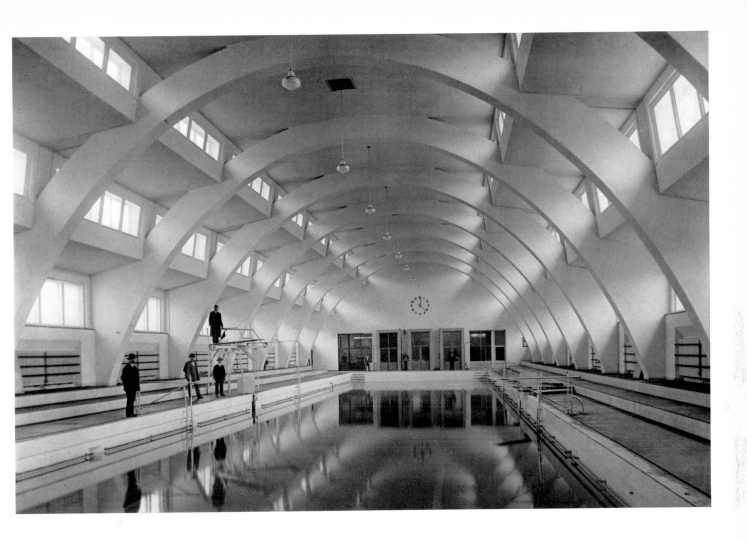

115
City architect's department, Stuttgart
Indoor swimming-pool, Heslach, Stuttgart, c. 1930

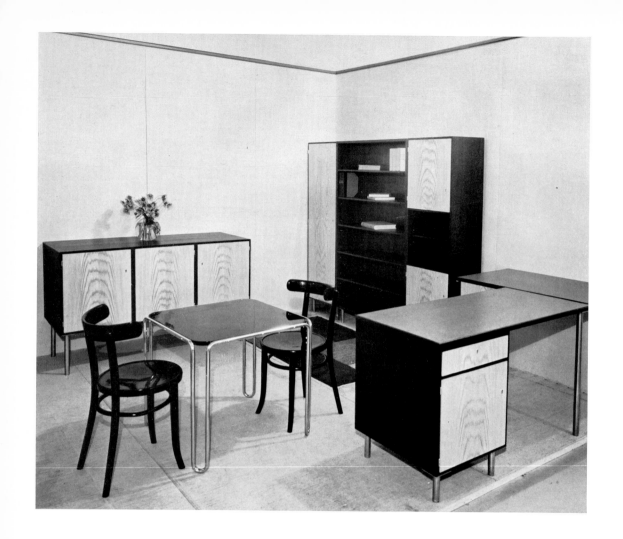

116
Walter Gropius
Furniture, Berlin, 1927

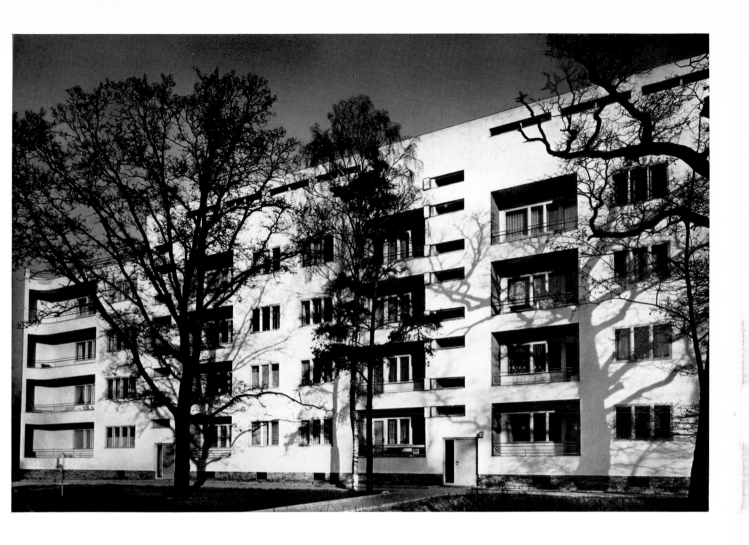

117
Hans Scharoun
Block of flats in Siemensstadt housing estate, Berlin
1929

118
Ernst May
Römerstadt housing estate, Frankfurt, 1928

VIII
Hans Leistikow
Detail of town plan of Frankfurt am Main,
showing new estates, 1930

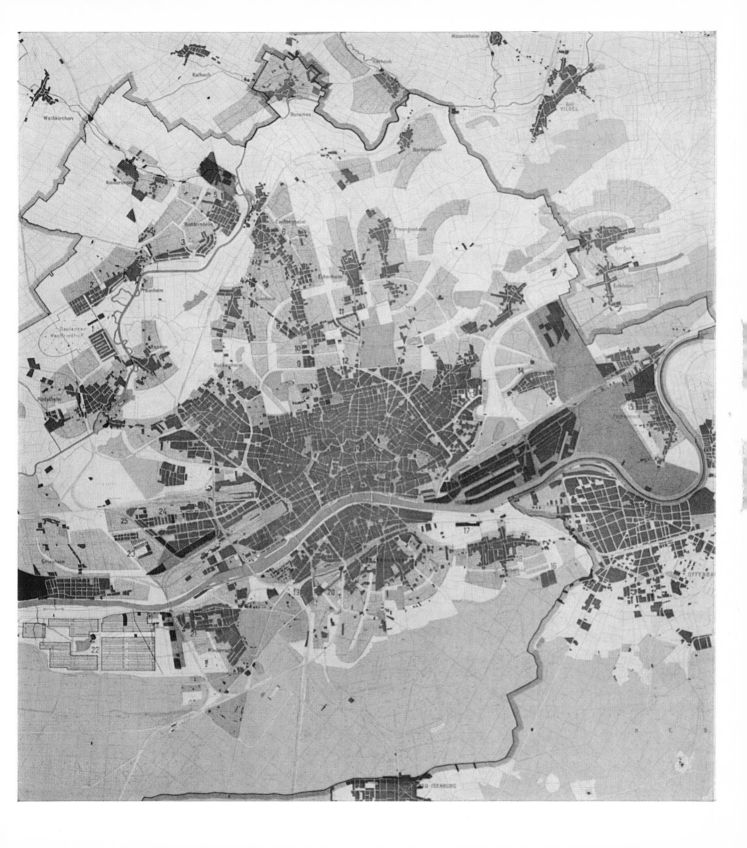

For the purposes of this book I have included only those artists of the thirties who were of general, rather than specialist, importance and whose work was particularly in tune with the spirit of contemporary design. I have also omitted artists—such as Hans Arp or Max Ernst—who worked almost exclusively in branches of art other than those dealt with here, or whose métier—for instance, the cinema—has been touched on only briefly.

Aalto, Alvar. Architect und furniture designer. Born 1898 in Kuortane, Finland. First buildings date from 1922. At first worked in Turku, later in Helsinki. Factories, public buildings, pavilions in various world exhibitions. After the Second World War continued working but in a wider field. Numerous buildings in Finland and abroad. Lives in Helsinki.
Aalto has had a very great influence on the development of modern architecture in Scandinavia, where his example is still followed today. His buildings have a natural rhythm, and the refinement and very good proportions of their design allow them to blend completely into their surroundings. The unforced naturalness of Aalto's houses is the product of an extremely sensitive logic, taken to its final conclusion.

Asplund, Erik Gunnar. Architect. Born 1885 in Stockholm. First buildings date from 1909. In 1913–14 he travelled in Italy and Greece, and this had an important influence on his work. Later he built several large public buildings in Sweden. Died in 1940 in Stockholm.
One can see in Asplund's work the transition from a sensitive neo-classicism to an architecture which is unreservedly modern. At the same time his later work still retains the serenity and beautiful proportions of his earlier period.

Bayer, Herbert. Painter, typographer, photographer, sculptor and architect. Born 1900 in Haag, Austria. 1921 to 1923, student at the Bauhaus in Weimar. 1925 to 1928, taught typography and advertising layout at the Bauhaus in Dessau. From 1928 he had his own studio in Berlin. Various commercial commissions, including exhibition design. 1938, emigrated to the United States. Continued working in a variety of fields, at first in New York, since 1946 in Aspen, Colorado.
Bayer's work as a photographer and commercial artist was especially typical of the period. His bold conceptions, ironic and elegant, were the expression of an enjoyment of life as self-confident as it was utterly sophisticated. Bayer succeeded in

popularizing the stimulus provided by Surrealist painting. In the early thirties he held a leading position in Germany.

Beaton, Cecil. Photographer, author, stage designer and dress designer. Born 1904 in London. In the late twenties and during the thirties he was fashion photographer for the American magazine 'Vogue'. Numerous portraits. In the fifties, he designed the scenery for the musical *My Fair Lady* and later for the film of the same name (1964). Lives in London.

Beaton can be regarded as the inventor of an artistic world all his own. In the thirties he developed a very individual style in his photographs (portraits and fashion plates). In these the models—like pieces of stage scenery—are displayed against an opulent background and with striking accessories. This method produces some surprisingly novel effects.

Bill, Max. Sculptor, painter, architect, designer, and journalist. Born 1908 in Winterthur. Studied from 1927 to 1929 at the Bauhaus in Dessau. From 1929 lived in Zürich. He was mainly a painter but also worked in closely-related fields. From 1951 to 1956 director of the Hochschule für Gestaltung in Ulm, for which he built a large group of buildings. Lives in Zürich.

Bill's creative works are distinguished by their rationality; they might be the artistic interpretations of mathematical laws. His concrete logic is capable of mastering almost all the disciplines of design.

Breuer, Marcel. Architect and furniture designer. Born 1902 in Pécs, Hungary. From 1920, student at the Bauhaus in Weimar. From 1924 director of the furniture class at the Bauhaus, with considerable influence on the development of the institute. Designed a great deal of furniture intended for manufacture with new materials. From 1928 practised as an architect in Berlin, designing villas and interiors. In 1935, emigrated to England, in 1937 moved to the United States and worked there with Walter Gropius until 1941. After the Second World War designed many large buildings. Lives in New York.

In Breuer's work functional features are expressed very directly. Construction, materials and formal detail are newly thought out each time. It is clear that he always understands the interrelationship of the parts of a building; this sometimes leads to details appearing more important than the whole.

Brinkman, Johannes Andreas. Architect. Born 1902 in Rotterdam. From 1925 worked with L. C. van der Vlugt, later with J. H. van den Broek. Various large buildings in the Netherlands. Died 1949.

The work of these architects combined specific tendencies of modern Dutch architecture: the use of only a few architectonic basic elements, and the expression of a sense of social responsibility. The resulting buildings display great candour and lucidity.

Cassandre, A. M. (pseudonym for Adolphe Mouron). Poster designer and stage designer. Born 1901 in Kharkov. Studied in Paris. From the middle of the twenties, numerous posters and commercial work. Later mainly stage designs. Died 1967 in Versailles.

Cassandre's work was influential internationally and was used as a model by the entire French commercial art world. It reflected his fascination with everything technological, and this produced exciting pictures with an almost magical quality. At the same time; his designs have a precisely captured gaiety.

Gropius, Walter. Architect und designer. Born 1883 in Berlin. From 1910 had his own studio in Berlin. Factory buildings and designs for industry. He founded the Bauhaus in Weimar in 1919, and was its direc-

tor until 1928. He designed new buildings for it in Dessau in 1925. His influence on this institute was paramount. From 1928 he again practised as an architect in Berlin. Planned large housing estates. In 1934 emigrated to England, designed several buildings there in collaboration with E. Maxwell Fry. In 1937 moved to the United States. In 1938 head of the architecture department of Harvard University, for which he designed a group of buildings. In 1945 founded TAC, a working community of architects, and was a member of it from then on. Numerous large buildings in the United States and abroad. Died 1969 at Harvard.

The influence of Gropius on the development of modern architecture was widespread, and was concerned with ethics as well as with design. Almost all his buildings were for public authorities, or were attempts to find new forms of public housing. Their social intent was expressed with an unpretentious realism.

Häring, Hugo. Architect and theoretician. Born 1882 in Biberach. From 1921, his own studio in Berlin, later director of a private art school. Designed only a few buildings. From 1943 again lived in Biberach, died there in 1958.

Häring advocated the theory of an organic building, which would develop naturally out of the requirements of any given case. He saw this as an alternative to the rigid ideas of design prevailing in the twenties. As this theory gained more general acceptance in the thirties, his influence became greater.

Hoyningen-Huené, George. Photographer. Born 1900 in the Baltic States. Began as a painter, later became a fashion and portrait photographer. From 1928 was on the staff of 'Vogue'. Died 1968 in Los Angeles.

Hoyningen-Huené was easily the most elegant fashion photographer of the thirties. His photographs have a natural grace, which softens their artificiality. The models in his photographs seem very real.

Jacobsen, Arne. Architect and designer. Born 1902 in Copenhagen. First buildings date from 1930. Close friendship with Gunnar Asplund was of great importance in his development. Various villas and medium-large buildings. After the Second World War numerous administrative buildings, town halls and schools, including St. Catherine's College, Oxford. Died 1971 in Copenhagen.

Jacobsen is the creator of an architecture that could be called 'civil'–in the best sense of the word. It combines urbanity with varied proportions. Its precision is unforced and lively.

Le Corbusier (pseudonym of Charles Edouard Jeanneret). Architect, painter and sculptor. Born 1887 at La Chaux de Fonds, Switzerland. Travelled extensively in Europe, where he met many important architects of the pre-war period. From 1917 lived in Paris, deeply involved in Cubist painting. Finally turned to architecture. From 1922 designed numerous houses, as well as large projects which were not carried out. Wrote various books and articles. During the thirties he produced mainly urban designs, of which the basic ideas were in part realized after the Second World War. After 1945 he built many important buildings in France and abroad. Died in 1965, during a holiday on the Mediterranean.

The architecture of Le Corbusier, which was functional in his own individual way, has a special place in the development of modern design. It was great architecture, spacious and very physical, but although it created great interest he had only a few direct followers (in Japan). Le Corbusier combines complexity and severity; for all his logic, his work also has an expressive value.

List, Herbert. Photographer. Born 1903 in Hamburg. At first in business, then took up photography in the thirties under the influence of the painter Andreas Feininger. From 1936, protracted visits to Paris, London and more especially, Greece. Numerous portraits, travel records and fashion photographs. Has lived in Munich since 1945.

List's photography is highly intense and introspective. The restrained tension of his pictures is governed by meticulously controlled gradations and contrasts of light and dark.

Luckhardt, Wassili and Hans. Architects. Born 1889 and 1890 in Berlin. Rapidly outgrew an early expressionist period. First buildings date from 1925. Various houses and administrative buildings, as well as designs for larger projects which never materialized. Enforced inactivity under the National Socialist government. After the Second World War resumed work in Berlin. Hans Luckhardt died there in 1954.

The comparatively few buildings of the Luckhardt brothers can be recognized by their elegant precision. They are always distinguished by a bright, lucid realism.

Mahlau, Alfred. Painter, poster designer and stage designer. Born 1894 in Berlin. Went to Lübeck in 1919, and was active there in a variety of fields. In 1940, returned to Berlin. From 1946, taught in Hamburg, where he died in 1967.

Mahlau's posters possess an exhilarating precision of form which is entirely characteristics of the period around 1930. He used astonishingly simple graphic techniques.

Mendelsohn, Erich. Architect. Born 1887 in Allenstein. First buildings around 1920, when he was still influenced by expressionism. Later built several departmental stores and other large buildings. In 1933, emigrated to England, then to Palestine, where he again designed numerous buildings. In 1941, moved to the United States. Designed a number of synagogues. Died 1953 in San Francisco.

Mendelsohn's architecture developed from an individualistic expressionism to an ever-increasing austerity and translucency; later he reverted somewhat to his earlier style. His most articulate buildings were those designed in the thirties, when his energy and mastery of design were at their height.

Mies van der Rohe, Ludwig. Architect. Born 1886 in Aachen. From 1912 had his own studio in Berlin. Designed several villas, as well as numerous bold projects which were not used. From 1926 to 1932, vice-president of Deutscher Werkbund. Director of the exhibition of the Werkbund in Stuttgart in 1927. From 1930 to 1933, director of the Bauhaus, which he was obliged to move from Dessau to Berlin, owing to political pressure, and which he finally had to close down. In 1938, emigrated to the United States. From 1938 to 1958, director of the architecture department of the Illinois Institute of Technology, Chicago, for which he designed several buildings. He also designed skyscrapers–flats and offices–in the United States. Died 1969 in Chicago.

The austere architecture of Mies van der Rohe, distinguished by its very great intellectual discipline and sense of design, has had an enormous influence all over the world. It combines constructional precision with great sensitivity to materials and proportions. The final outcome of his designs was invariably definitive; they were models for the design of this century in a way that probably no other creative work has been.

Neutra, Richard. Architect. Born 1882 in Vienna. At first was under the influence of the Vienna 'Moderns'. After the First World War collaborated briefly with Erich Men-

delsohn in Berlin. In 1923, emigrated to the United States and was employed there by Frank Lloyd Wright. From 1927, ran his own firm in Los Angeles. Numerous commissions, particulary villas in California. Later larger buildings as well. Died in 1970, while travelling in Germany.

Neutra's boldly planned houses combine spacious elegance and clear articulation of detail. Their open disposition blends effortlessly into the landscape.

Peterhans, Walter. Photographer. Born 1897 in Frankfurt am Main. After a varied education he taught photography from 1929 to 1933 at the Bauhaus in Dessau and Berlin. He then freelanced. In 1938 he emigrated to the United States. There he taught visual training at the Illinois Institute of Technology in Chicago. After 1945 he undertook lecture tours in America and Germany. Died 1960, near Stuttgart.

The photographs of Peterhans are minutely-observed compositions, which give an appearance of casualness which is deceptive. The extreme degree of calculation underlying them has led to the subject-matter seeming somewhat alienated and dematerialized.

Ray, Man. Painter, photographer and sculptor. Born 1890 in Philadelphia. At first studied architecture in New York, later turned to painting. From 1921 lived in Paris. Associated with the Dadaists and the Surrealists; he took an increasing interest in photography. In 1934 he invented the rayogram, a process of projecting figures onto light-sensitive paper without the use of a camera. Numerous portraits, and from 1926 films as well. In 1940 went to Hollywood, returning to Paris in 1950.

Man Ray discovered how to link Surrealism directly to photography. His pictures, at whatever range they are taken, have always a certain air of remoteness.

The severity of their design is exalted and transformed in an intensely graphic way.

Renger-Patzsch, Albert. Photographer. Born 1897 in Würzburg. Later lived in Essen, where he was a teacher from 1933 at the Folkwang school of design. Various photographic commissions for industry. Died in 1966.

Renger-Patzsch had great influence on the development of photography in Germany. His austerely beautiful photographs of landscapes, townscapes and utilitarian objects possess an unusual density, free from any trace of 'mood' or anecdote.

Scharoun, Hans. Architect. Born 1893 in Bremen. Was closely associated with the Expressionists in Berlin in the period after the First World War. In the early thirties he designed several large housing projects in Berlin. Enforced inactivity under the National Socialist regime. After the Second World War, he had great influence on the architectural development of Berlin. Has designed several large public buildings. Lives in Berlin.

Echoes of expressionism invest Scharoun's work with an elegant dynamic, in which self-expression still predominated in the thirties; later this grew less noticeable.

Schweizer, Otto Ernst. Architect. Born 1890 in Schramberg. At first a geometrician, then took up architecture. Designed his own buildings, from 1919. Appointment with the city of Nuremberg in 1925. Designed various large public buildings. From 1930, taught in Karlsruhe. Enforced inactivity under the National Socialist regime. A few buildings after the Second World War. Died 1965 in Baden-Baden.

Schweizer's buildings during the thirties were actively ascetic. They combine extreme brevity of detail with great freedom in the design as a whole. Their concise and simple forms produce an effect of very great naturalness.

Steichen, Edward. Photographer and painter. Born 1879 in Luxembourg. Has lived since 1881 in the United States. First photographs date from 1899. Lived a great deal in France before the First World War. From 1911, fashion photographer. From 1923 to 1938, chief photographer for the American fashion magazines *Vogue* and *Vanity Fair*. In 1945–46, director of the photographic unit of the US Marine Corps. From 1947 to 1962, director of the photographic department of the Museum of Modern Art in New York, where he organized the photographic exhibition 'The Family of Man'. Lives in Connecticut, USA. The development of photography in the first half of the twentieth century is reflected in the work of Steichen. After early work influenced by impressionism, he embarked upon a close study of nature and became a distinguished portrait and fashion photographer, noted for his restraint, psychological sensitivity and preference for moderate tones.

Terragni, Giuseppe. Architect. Born 1904 in Meda near Milan. A member of the Novecento Italiano, a group of Fascist artists. With other young architects formed Gruppo 7. First buildings date from 1927. Villas, interiors and designs for exhibitions. Died 1942 at Como.
Terragni's work was influenced by the conflicting conditions of the Fascist era. On the one hand was an attempt to find a link with international modern development, on the other there was pressure to express the ruling political philosophy. Terragni managed to settle for a clear, precise, unpretentious architecture without compromises.

Colour

I Hans Arp: Ace of Spades tapestry, 1930. Knotted, 212×150 cm. Die Neue Sammlung, Munich.

II Pierre Masseau: Poster for French state railways (Chemins de Fer de l'Etat), 1931. Lithograph, 98×61 cm. Die Neue Sammlung, Munich.

III A. M. Cassandre: Poster for an electrical firm, Paris, 1931. Lithograph, 119×80 cm. Die Neue Sammlung, Munich.

IV A. M. Cassandre: Poster for an ocean liner, Paris, 1931. Lithograph, 99×61 cm. Die Neue Sammlung, Munich.

V Alfred Mahlau: Travel poster, Lübeck, 1929. Lithograph, 100×62 cm. Die Neue Sammlung, Munich.

VI A. M. Cassandre: Poster for French state railways (Chemins de Fer de l'Etat), Paris, 1929. Lithograph, 100×62 cm. Die Neue Sammlung, Munich.

VII Max Ernst: Interior, Corso-Bar, Zürich, 1934. The murals have been detached and are now in the Kunsthalle, Zürich.

VIII Hans Leistikow: Detail of town plan of Frankfurt am Main, showing new estates, 1930. Those already built are in red, those planned are in pink. Published as a supplement to the journal *das neue frankfurt*. Lithograph; total size 68×94 cm.

Monochrome

1 Ludwig Mies van der Rohe: German Pavilion at the International Exhibition in Barcelona, 1929. Walled courtyard, with a statue by Georg Kolbe, as the culmination of an open sequence of rooms. The building was planned to last for the duration of the exhibition and was then dismantled. (See also pl. 17.)

2 Million-Guiet: Coachwork of Panhard-Levassor motor-car, France, c. 1930.

3 George Hoyningen-Huené: Fashion photograph for *Vogue*, Paris, 1934. Taken in the magazine's Paris studio. By kind permission of Condé-Nast Publications Inc., New York.

4 Herbert Bayer: Title-page of the magazine *bauhaus*, 1928. Produced at the Bauhaus in Dessau.

5 Otto Ernst Schweizer: Nuremberg Stadium, 1928. Entrance-hall at the back of a stand. (See also pl. 24.)

6 Ludwig Mies van der Rohe: Chair, 1929. Designed for the German pavilion at the Barcelona Exhibition. Chromium and leather. Now produced by Knoll International.

7 Andreas Moritz: Handwrought silver cutlery, 1928. Length of knife 24.5 cm. Die Neue Sammlung, Munich.

8 Peter Birkhäuser: Poster for the fashion house PKZ, Zürich, 1934. Colour lithograph, 128×90 cm. Kunstgewerbemuseum, Zürich.

9 Rolls-Royce, England: Springfield Phantom I motor-car, 1929. Special York body on chassis S 400 LR.

10–11 Edward Steichen: Fashion photographs for Vogue, 1930. Taken in the magazine's New York studio. By kind permission of Condé-Nast Publications Inc., New York.

12 Le Corbusier and Charlotte Perriand: Chair with adjustable back, Paris, 1929. Exhibited for the first time at the 1929 Salon d'Automne. Chrome tubular steel, leather and fur. The chair is now manufactured by Cassina, Milan.

13 Alvar Aalto: Library, Viipuri, Finland, 1927. Main entrance. The building was destroyed in the Second World War.

14 Trude Petri: Urbino china dinner-service, 1930. Later manufactured by the Staatliche Porzellan-Manufaktur, Berlin.

15 Max Bill: Poster for an exhibition of primitive art, Zürich, 1931. Lino-cut in two colours, 128×91 cm. Kunstgewerbemuseum, Zürich.

16 Adolf Loos: Set of glassware, 1933. With a chequered pattern cut on the base. Since manufactured by J. & L. Lobmeyr, Vienna.

17 Ludwig Mies van der Rohe: German Pavilion at the International Exhibition in Barcelona, 1929. Entrance. (See also pl. 1.)

18 George Hoyningen-Huené: Fashion photograph for Vogue, 1933. Taken in the magazine's Paris studio. By kind permission of Condé-Nast Publications Inc., New York.

19 Ludwig Mies van der Rohe: Tugendhat House, Brno, 1930. Group of seats in the large living-room. In the background a semicircular soaring wooden wall divides off the dining-room. The interior of the house was destroyed in the Second World War, but there are plans to reconstruct it. (See also pl. 41.)

20 Le Corbusier and Charlotte Perriand: Adjustable couch, Paris, 1929. Exhibited for the first time at the 1929 Salon d'Automne. Chrome, tubular steel, iron lacquered black, leather and fur. The couch is now manufactured by Cassina, Milan.

21 Giuseppe Terragni: Casa del Popolo, Como, 1932. Entrance side.

22 Hans Aeschbach: Poster for an arts and crafts students' exhibition, Zürich, 1929. Coloured lithograph, 127× 89 cm. Die Neue Sammlung, Munich.

23 Richard Neutra: Health House, Los Angeles, 1928. Living-room. (See also pl. 61.)

24 Otto Ernst Schweizer: Nuremberg Stadium, 1928. Rear of the large wing containing the stands. (See also pl. 5.)

25 Junkers Flugzeugwerke, Germany: Passenger cabin of G 38 airliner, 1929. (See also pl. 51.)

26 George Hoyningen-Huené: Fashion photograph for *Vogue*, 1932. Taken in the magazine's Paris studio. By kind permission of Condé-Nast Publications, Inc., New York.

27 Wassili and Hans Luckhardt: House, Velten, near Berlin, 1932.

28 Alfred Mahlau: Travel poster, Lübeck, 1931. Lithograph in two colours, 73× 50 cm. Die Neue Sammlung, Munich.

29 Marcel Breuer: Wohnbedarf furniture store, Zürich, 1933. The store sells furniture designed by well-known architects. The sofa is by Alvar Aalto, the movable service trolley by Alfred Roth, the round table, designed for home assembly, by M. Moser, the other chairs by Marcel Breuer.

30 Marguerite Friedlaender: Two china teapots, the smaller with a silver handle, 1930. Made by the Staatliche Porzellan-Manufaktur, Berlin.

31 Rudolf Schwarz, with Hans Schwippert and Johannes Krahn: Fronleichnamskirche, Aachen, 1930. Photograph by Albert Renger-Patzsch.

32 Wilhelm Poetter: Cigarette poster, Essen, 1929. Monochrome offset, 142×95 cm. Die Neue Sammlung, Munich.

33 German state railways (Deutsche Reichsbahn), design department, Cologne: Two-track railway bridge over the Rur near Düren, 1929. The span measures 78 m., height 14.50 m.

34 Ludwig Mies van der Rohe: Chair, designed for the Tugendhat House in Brno, 1930. Chromium and leather. The illustration shows a version of the chair which differs from the original, but it is the one now manufactured by the firm Knoll International.

35 J. W. Kehr: Offices for the journal *Volksstimme*, Frankfurt, 1929.

36 Alvar Aalto: Printing-house for the journal *Turun Sanomat*, Turku, Finland, 1927. The main machine-room.

37 Walter Gropius: Coachwork of Adler motor-car, Germany, 1930. There were several variants including a two-door cabriolet.

38 Le Corbusier and Pierre Jeanneret: Swiss student hostel in the Cité Universitaire, Paris, 1930. The glazed south side has been altered in recent times by the addition of blinds. (See also pl. 48.)

39 A. M. Cassandre: Poster for safety glass, Paris, 1931. Coloured lithograph, 120×79 cm. Die Neue Sammlung, Munich.

40 Emil Lettré: Silver cutlery, 1932. Since manufactured by P. Bruckmann & Söhne, Heilbronn. Length of knife, 22.5 cm.

41 Ludwig Mies van der Rohe: Tugendhat House, Brno, 1930. Drawing-room with a view of winter garden. (See also pl. 19.)

42 O. H. W. Hadank: Cigarette poster, c. 1930. Coloured lithograph, 167× 119 cm. Die Neue Sammlung, Munich.

43 Henry Binder: Coachwork of Rolls-Royce Phantom II motor-car, 1929. On 89 WJ chassis.

44 Fritz August Breuhaus de Groot: Smoking-room in the airship *LZ 129 (Hindenburg)*. The passengers' quarters were underneath the gasbag; outside the railing there were almost horizontal viewing windows. The architect had to comply with the need to keep the fittings as light as possible. This Zeppelin was destroyed by fire in 1937 while landing at Lakehurst near New York.

45 Herbert Bayer: Title-page of the magazine *die neue linie*, Berlin, 1931. Coloured letterpress, 36.5×27 cm.

46 Herbert Bayer: Title-page of the magazine *die neue linie*, Berlin, 1930. Coloured letterpress, 36.5×27 cm.

47 Hans Scharoun: Hostel for bachelors, Breslau, 1929. Built on the occasion of the exhibition of the Werkbund in Breslau (now Wroclaw). View from the roof garden over the entrance area below. (See also pl. 107.)

48 Le Corbusier and Pierre Jeanneret: Swiss student hostel in the Cité Universitaire, Paris, 1930. The rear of the building with the warden's apartment and the staircase. (See also pl. 38.)

49 Hans Scharoun: Schminke House, Löbau, Silesia, 1932. View from the living-room into the winter garden. (See also pl. 53.)

50 E. Owen Williams: Boots' pharmaceutical factory, Beeston, Nottingham, England, 1930.

51 Junkers Flugzeugwerke, Germany:

G 38 airliner *Generalfeldmarschall von Hindenburg*, 1930.

52 A. M. Cassandre: Poster for a luxury train, Paris, 1929. Coloured lithograph, 99×62 cm. Die Neue Sammlung, Munich.

53 Hans Scharoun: Schminke House, Löbau, Silesia, 1932. View towards the winter garden. (See also pl. 49.)

54 Josef Frank: Tearoom, Vienna, 1930, built in Österreichisches Museum für Kunst und Industrie on the occasion of the exhibition of the Werkbund in Vienna.

55 Erik Gunnar Asplund: Stockholm Exhibition, 1930. Main entrance. (See also pl. 57.)

56 A. M. Cassandre: Poster for an ocean liner, Paris, 1928. Coloured lithograph, 103×76 cm. Die Neue Sammlung, Munich.

57 Erik Gunnar Asplund: Paradise Restaurant, Stockholm Exhibition, 1930. (See also pl. 55.)

58 Le Corbusier and Pierre Jeanneret: Villa Savoye, Poissy, near Paris, 1928. Garden court at first-floor level with view over the roofs below.

59 A. M. Cassandre: Poster for a Channel ferry, Paris, 1931. Coloured lithograph, 100×62 cm. Die Neue Sammlung, Munich.

60 Dornier-Flugzeugwerke, Germany: Do-X flying boat, 1929. Wingspan 48 m., length 40 m.

61 Richard Neutra: Health House, Los Angeles, 1927. (See also pl. 23.)

62 German state railways (Deutsche Reichsbahn): The diesel train 'Fliegender Hamburger', 1933. The train travelled between Berlin and Hamburg. It was equipped with Maybach motors; the bodywork was by Wumag, Görlitz.

63 Pier Luigi Nervi: Stadium, Florence, 1930. Entrance to the stands.

64 Alfred Willimann: Poster for an exhibition of lighting systems, Zürich, 1932. Monochrome lithograph, 127 × 89 cm. Die Neue Sammlung, Munich.

65 Erich Mendelsohn: Schocken department store, Chemnitz, 1927.

66 Dutch state railways (Nederlandsche Spoorwegen): Diesel units, 1935. Maybach motors, bodywork by Werkspoor of Amsterdam.

67 A. M. Cassandre: Poster for a luxury train, Paris, 1927. Coloured lithograph, 105 × 75 cm. Die Neue Sammlung, Munich.

68–69 Alvar Aalto: Sanatorium in Paimio, Finland, 1929. Stair well and west side with main entrance.

70 Hans Kruckenberg: Schienenzepp experimental train, 1930. Built for the German state railways (Deutsche Reichsbahn).

71 Giovanni Michelucci and collaborators (Baroni, Berardi, Gamberini, Guarniere, Lusanna): Santa Maria Novella railway station, Florence, 1933. Booking-hall.

72 Johannes Andreas Brinkman and L. C. van der Vlugt, with Mart Stam: Van Nelle tobacco factory, Rotterdam, 1928.

73 Albert Renger-Patzsch: Railway embankment, Essen, 1930. Photograph.

74 Edward Weston: Wrecked car, North America, 1931. Photograph.

75 Man Ray: Elsa Schiaparelli, Paris, 1930. Photograph.

76 Albert Renger-Patzsch: Street, Essen, 1932. Photograph.

77 Alfred Stieglitz: Lake George, 1934. Photograph.

78 Walter Peterhans: Photographic study, Dessau, c. 1930. Made at the Bauhaus.

79 Hildegard Heise: Coffee garden on the river Saale, Halle, 1929. Photograph.

80 Brassaï: Man with white sunshade, Menton, 1935. Photograph.

81 Walter Peterhans: Photographic study, Dessau, c. 1930. Made at the Bauhaus.

82 Cecil Beaton: Photograph, London, c. 1930.

83 Herbert List: The Slave-girl, London, 1934. Photograph.

84 Josef von Sternberg: Still from the film *Shanghai Express*, with Marlene Dietrich, Hollywood, 1932.

85 Henri Cartier-Bresson: Photograph, Mexico, 1934.

86 Walter Peterhans: Photographic study, Dessau, c. 1930. Made at the Bauhaus.

87 Herbert Bayer: Creative Hands, 1932. Photomontage.

88 Herbert List: The Moustache, Hamburg, 1931. Photograph.

89 Fritz Lang: Scene from the film M, Germany, 1930.

90 Herbert Bayer: Self-portrait, Berlin, 1932. Photomontage.

91 René Clair: Scene from the film A nous la liberté, France, 1930.

92 Niklaus Stoecklin: Poster for the fashion house PKZ, Zürich, 1934. Coloured lithograph, 128×90 cm. Kunstgewerbemuseum, Zürich.

93 Edward Steichen: Photograph for Vogue, New York, 1934. Taken to illustrate an article on the care of the body.

94 Xanti Schawinski: Advertisement for a fashion house, Milan, 1934. The first design for this originated in 1927. Printed in two colours, 34×24.5 cm.

95 Walter Peterhans: Photographic study, Dessau, c. 1930. Made at the Bauhaus.

96 Marcel Breuer: S 32 chair, Germany, 1927. Chrome, steel tubing, wood, and wickerwork. At first Breuer made chairs from stiff gas-piping; then with the more elastic steel tube he changed them into a shape without back legs, which could give. But the design patent was awarded to the architect Mart Stam. The chair has been made by the Thonet firm in Germany since 1927.

97 Weissenhof housing estate, Stuttgart, 1927. It was created as an exhibition for the Deutscher Werkbund with almost all the leading architects of Europe taking part. The overall plan was the work of Ludwig Mies van der Rohe, who also built the apartment house which forms the centre-point of the whole layout. Others who took part were Le Corbusier, Oud, Stam, Bourgeois, Frank, Gropius, Hilbersheimer, Döcker, Taut, Rading, Schneck, Scharoun, Behrens, Poelzig. Only part of the estate still stands in its original form.

98 Wilhelm Wagenfeld: Fireproof glassware, 1932. Since manufactured in slightly modified form by the Jena glass factory Schott & Gen.

99 Werner M. Moser, Carl Hubacher, Emil Roth, Rudolf Steiger, Hans Schmidt, Paul Arteria: Neubühl housing estate, near Zürich, 1930. Built for the Werkbund. Overall view from the north-west. The houses descend in stepped levels to the lakeshore, which is just out of sight in the foreground.

100 Hermann Gretsch: Arzberg 1382 chinaware, 1931. It was the first well-designed china service available at a low price. Has been produced ever since by the Arzberg china firm in Upper Franconia, and still accounts for a considerable proportion of their production.

101 Walter Gropius: Flats in Siemensstadt housing estate, Berlin, 1929.

102 Mogens Kock: Folding chair, Denmark, 1933. Wood, sailcloth and brass fittings. Manufactured since then by the firm Interna, Denmark.

103 Olof Thunström: Hästholmen housing estate, near Stockholm, 1932.

104 Johannes Andreas Brinkman and J. C. van der Vlugt: Bergpolder apartment block, Rotterdam, 1933. View from the north-west showing staircase and liftshaft.

105 Gebrüder Thonet AG: Chair, Austria, c. 1930. Wood and wickerwork, with metal fittings for strength. It is possible that the design of this chair is by Josef Hoffmann.

106 Ebbe Sadolin: Chinaware, 1932. Manufactured since by the Royal Porcelain Factory, Copenhagen.

107 Hans Scharoun: Hostel for bachelors, Breslau, 1929. Built on the occasion of the exhibition of the Werkbund. (See also pl. 47.)

108 Hugo Häring: Flats in Siemensstadt housing estate, Berlin, 1930.

109 Werner M. Moser: Chair, 1929. Wood and wickerwork. Since then manufactured by the Horgen-Glarus firm, Glarus, Switzerland.

110 Alvar Aalto: Stacking chair, c. 1930. Birchwood. Aalto designed numerous chairs which were all based on the new bentwood technique. They are manufactured by the Artek firm in Finland.

111 Arne Jacobsen: Bellavista flats, Klampenborg, near Copenhagen, 1932. The blocks are part of a larger complex, which also includes a theatre. The flats have a view over the Sound.

112 Hans Scharoun: Blocks of flats in Siemensstadt housing estate, Berlin, 1929. (See also pl. 117.)

113 Robert Vorhoelzer and Walther Schmidt: Post office, Munich, c. 1930. Parts of the interior design were shown at the Deutscher Werkbund exhibition in Paris. (See also pl. 114.)

114 Robert Vorhoelzer and Walther Schmidt: Block of flats with post office, Munich, c. 1930. (See also pl. 113.)

115 City architect's department, Stuttgart: Indoor swimming-pool, Heslach, Stuttgart, c. 1930.

116 Walter Gropius: Furniture, Berlin, 1927. Shown 1930 at the Deutscher Werkbund exhibition in Paris, these designs were developed for the Feder department store in Berlin.

117 Hans Scharoun: Block of flats in Siemensstadt housing estate, Berlin, 1929. (See also pl. 112.)

118 Ernst May: Römerstadt housing estate, Frankfurt, 1928.